Renaissance
Masterpieces of Art

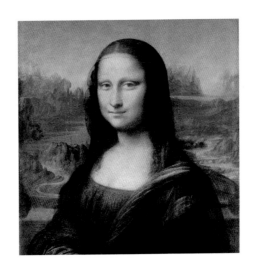

Publisher & Creative Director: Nick Wells
Senior Project Editor: Catherine Taylor
Copy Editor: Daniela Nava
Art Director: Mike Spender
Layout Design: Federica Ciaravella
Digital Design & Production: Chris Herbert

Special thanks to Dawn Laker, Eileen Cox, Jeremy Werner, Frances Bodiam.

FLAME TREE PUBLISHING
6 Melbray Mews
Fulham, London SW6 3NS
United Kingdom

www.flametreepublishing.com

First published 2019

19 21 23 22 20
1 3 5 7 9 10 8 6 4 2

Image credits: Courtesy of **Bridgeman Images** and the following: Staatsbibliothek, Berlin, Germany/De Agostini Picture Library 3 & 74; Galleria degli Uffizi, Florence, Tuscany, Italy 4 & 86, 7, 26 & 116, 30, 33, 58, 63, 76, 73 & 77, 80, 95, 117, 119; Scrovegni (Arena) Chapel, Padua, Italy 9 & 31; Santa Maria del Carmine, Florence, Italy 11 & 38; National Gallery, London, UK 12 & 53, 27 & 40, 28 & 56, 48, 64, 70, 82, 92, 98, 118; Palazzo Ducale & Museo, Mantua, Lombardy, Italy/De Agostini Picture Library/M. Carrieri 13 & 62; Santa Maria delle Grazie, Milan, Italy 17 & 90; Vatican Museums and Galleries, Vatican City 20 & 105, 36, 102; Gallerie dell'Accademia, Venice, Italy/Cameraphoto Arte Venezia 22, 23b & 124; Scuola Grande di San Rocco, Venice, Italy 23t &122; Vatican Museums and Galleries, Vatican City/Artothek 24 & 107; Church of Santa Felicita, Florence, Italy/De Agostini Picture Library 25; Museo dell'Opera del Duomo, Siena, Italy 32; Santa Croce, Florence, Italy 34; Brancacci Chapel, Santa Maria del Carmine, Florence, Italy 37; Santa Maria Novella, Florence, Italy 41, 84; Museo di San Marco, Florence, Italy 42, 43, 47; Louvre, Paris, France 44, 68, 79, 94; Photo © Luisa Ricciarini 45; De Agostini Picture Library/G. Dagli Orti 46; Church of San Lorenzo, Chapel Martelli/Photo © Luisa Ricciarini 50; Rome Galleria Barberini/Photo © Luisa Ricciarini 51; Alte Pinakothek, Munich, Germany/Tarker 52; De Agostini Picture Library 54; Gemaldegalerie, Staatliche Museen zu Berlin, Germany/De Agostini Picture Library 57; Pinacoteca, Sansepolcro, Italy 59; Ashmolean Museum, University of Oxford, UK 60; Frick Collection, New York, USA 66; Pinacoteca di Brera, Milan, Italy 67; San Zaccaria, Venice, Italy/Cameraphoto Arte Venezia 71; Museo Poldi Pezzoli, Milan, Italy 78; Thyssen-Bornemisza Collection, Madrid, Spain 85; Czartoryski Museum, Cracow, Poland 87; Alte Pinakothek, Munich, Germany/De Agostini Picture Library 88; Louvre, Paris, France/Photo © Youngtae 89; Musee des Beaux-Arts, Caen, France 93; Kunsthistorisches Museum, Vienna, Austria 96, 113; Galleria Borghese, Rome, Lazio, Italy 97; Isabella Stewart Gardner Museum, Boston, MA, USA 108 & 121; Santa Maria Gloriosa dei Frari, Venice, Italy 110; Mondadori Portfolio/Electa/Sergio Anelli 111; Parma, Galleria Nazionale/Photo © Luisa Ricciarini 114; Prado, Madrid, Spain 115. Courtesy of **Metropolitan Museum of Art, New York** and the following: Rogers Fund, 1918 16. Courtesy of **Shutterstock.com** and the following: EQRoy 8; muratart 18; DFLC Prints 19; Yuriy Biryukov 106 & 128. Courtesy of **SuperStock** and the following: A. Burkatovski/Fine Art Images 112; World History Archive 120. **Wikimedia Commons** and the following: Public Domain 6 & 100, 21 & 104, 99; Didier Descouens/CC BY-SA 4.0 15 & 69; Zenodot Verlagsgesellschaft mbH/GNU Free Documentation License 65; Alvesgaspar/CC BY-SA 4.0 106.

ISBN: 978-1-78755-696-6

Printed in China | Created, Developed & Produced in the United Kingdom

Renaissance
Masterpieces of Art

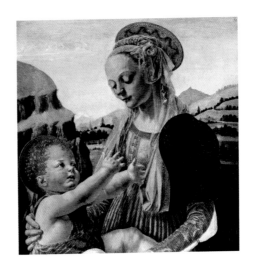

Julia Biggs

**FLAME TREE
PUBLISHING**

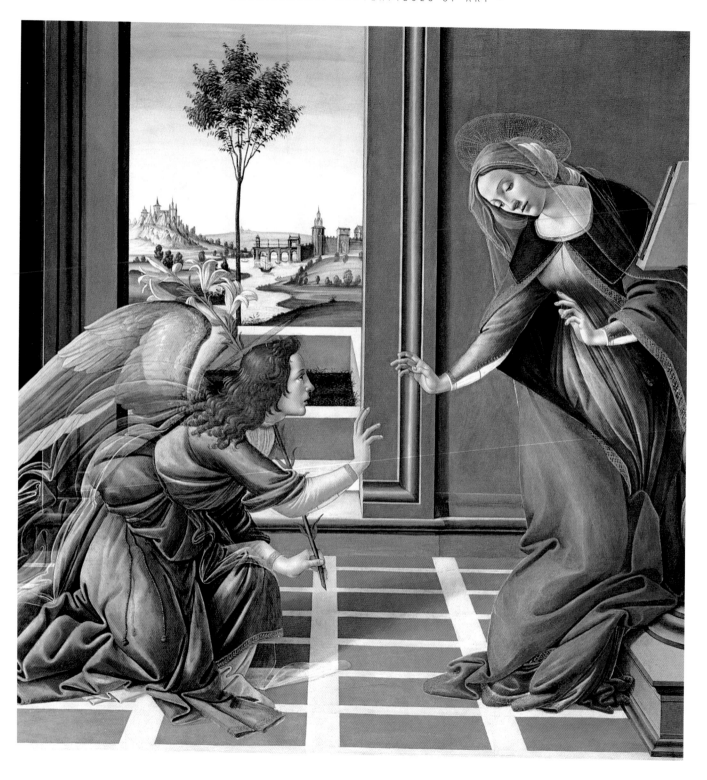

Contents

The Renaissance: Innovation & Creativity

Literally meaning 'rebirth', the word renaissance refers to the intellectual, economic and artistic changes that began in Italy in the fourteenth century and reached its pinnacle there in the sixteenth century. It is also associated with that period's revival of interest in the Classical worlds of ancient Greece and Rome. The term was not used until the nineteenth century (it was first coined by the French historian Jules Michelet in 1855), but the painter and probably the first proper art historian Giorgio Vasari (1511–74) believed there had been a renewal of the arts in Italy and that they had, by his day, reached perfection. The Renaissance witnessed the discovery of mathematical perspective, advances in the understanding of architectural design and sculptural form, and the development of new themes, as well as media such as fresco and oil painting. It gave us the concept of the artist as a creative genius and some of the most powerful and popular artworks of all time.

Vasari and the Renaissance Myth

Understanding Renaissance art means paying attention to how prior writing on the subject conditions our response to it. The man whose approach continues to influence popular perceptions of the Renaissance today, for better or for worse, is Giorgio Vasari. In his *Lives of the Most Excellent Painters, Sculptors and Architects*, published in 1550 and 1568, Vasari 'branded' the history of Renaissance art, presenting it as a progressive series of qualitative peaks and valleys, or 'ages' as he called them. According to Vasari, after the excellence of the arts of the Greeks and Romans, there followed a depressing decline and the 'barbarian' style of the dark Middle Ages. This was in turn reversed by a revival of the arts in Tuscany (Vasari's native region) in the fourteenth century, which

blossomed in the fifteenth century and culminated in the sixteenth century with Michelangelo Buonarotti (1475–1564).

There is something comforting about this vision of the Renaissance as a period of enlightenment, which perhaps explains why it has taken so long for art historians to question Vasari's myth. The surviving evidence from the Renaissance period suggests a far from straightforward cultural situation. Although this book employs a loose chronological framework to provide a coherent overview, it also stresses

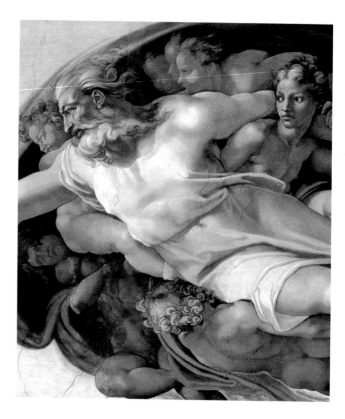

the continuities between historical periods and styles rather than the disjunctions noted by writers like Vasari.

The Proto-Renaissance

The art historical period of 1200–1400 has many different names: Proto-Renaissance, Late Medieval, or simply the thirteenth and fourteenth centuries (known in Italian as the *Duecento* and the *Trecento*). This highly creative pre-Renaissance era, which had its stylistic roots in Byzantine, Early Christian and Roman art and sculpture, also saw painters pioneer new approaches.

Where the Proto-Renaissance occurred is important. Italy at this time was a collection of city-states, each with their own government (some were republics and others were ruled by despots). Many of these city-states, centres for trade and commerce that also allowed for a busy exchange of ideas, accumulated extraordinary wealth and provided the financial support for a growing number of art projects. The Roman Catholic Church – the biggest patron of the arts – was also extending its political and economic power, while at the same time weathering a crisis which saw, at one point, three popes excommunicate one another!

It was during this period that the Black Death arrived on European shores. The plague, which swept through Italy from 1348 to 1350, killed approximately half of the region's population. It turned every aspect of life upside down and

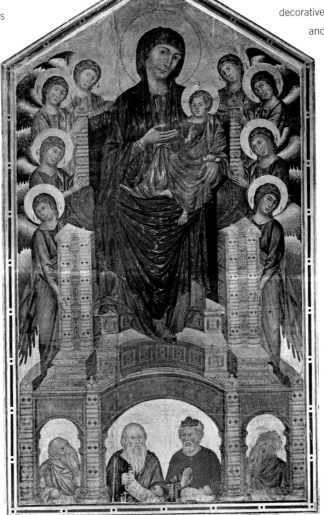

disrupted trade, manufacturing and arable production. Some historians argue that the radical social and economic changes that emerged in the aftermath of these years of devastation contributed to the rapid developments of the Renaissance in Italy after 1400. This can be debated, but what is certain is that the ultimate reaction to the Black Death was a rebirth of belief in man, nature and a benevolent God.

It is, therefore, unsurprising that much of the remaining Proto-Renaissance art we have is in the form of altarpieces or parts of altarpieces that decorated the apses of churches or individual chapels. The donors of these works, often newly wealthy middle-class families, did not see them as just decorative images to be admired for their style and composition. Instead, altarpieces were intended to be actively used in the rituals related to the Masses said daily before them. The typical materials used to create altarpieces were wooden panels, which were covered with a layer of *gesso* (a mixture of ground plaster and glue) to form a smooth surface on which egg-based tempera paint was applied in short, repeated strokes.

The Painter's Workshop

Artists operated in a workshop (*bottega*), which was part of a broader economic landscape partially regulated by a trade group known as a guild. Guilds limited outside competition, determined how many apprentices an artist could have and set out the route to become an established artist. They also guaranteed patrons a certain level of capability.

A workshop produced goods and competed for commissions that were secured and paid for through contracts between artists and patrons. Surviving contracts reveal that, although the skill of the artist was important in commissioning and producing a work, the patrons were just as impressed by the materials used. Contracts frequently stipulated the quality of the pigments and how much gold leaf or ultramarine blue made from crushed lapis lazuli should be employed. They also specified a final date for completion of the work and terms of payment.

In many cases workshops passed from father to son or uncle to nephew, from generation to generation. At the head of the organization was the master, an experienced independent artist. Under the master's charge were the apprentices, who seem to have entered the artists' shops in their early teens, although some boys – called *garzoni* – were placed with a master before they were 10 years old, becoming part of the extended household and receiving a modest wage. The time apprentices spent in the shop varied. The Florentine artist Cennino Cennini (*c.* 1370–*c.* 1440) recommended at least six years.

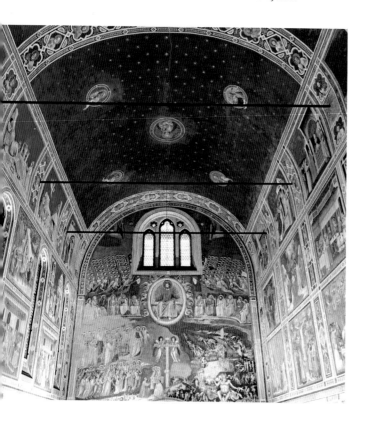

In exchange for their assistance in the workshop, the master would give his pupils training in his particular craft. Pupils began with menial tasks such as preparing panels and grinding pigments. They then learned to draw, first copying drawings made by their masters and other artists and then drawing from statuettes or casts. Once a pupil had progressed to painting, he would concentrate on executing less important parts of a work, such as bits of landscape background, in the master's style. When an artist was fully trained and experienced, he would try to find commissions, set up a shop for himself and eventually take on his own apprentice or apprentices.

The Step Towards Naturalism

Italian artists and poets were inspired by the example of Saint Francis of Assisi (*c.* 1181–1226), who had rejected Scholasticism (the system of philosophy, theology and teaching that dominated Medieval Western Europe), personalized the religious experience and gone out among the poor extolling the beauties and spiritual value of nature. His example encouraged artists to take pleasure in the world around them and explore human emotion.

A new style began to emerge as artists moved away from the tradition of Byzantine art. The Roman artist Pietro Cavallini (*c.* 1250–*c.* 1330) created mosaics and frescoes featuring solid figures in deep architectural settings and well-ordered compositions. The sculptor Nicola Pisano (*c.* 1220–78) studied ancient Roman sarcophagi, and his classical pulpit for Pisa's Baptistery (1260) is thought by many to signal a major turning point in Western sculpture.

The conservative Sienese school of painting led by Duccio di Buoninsegna (*c.* 1255–*c.* 1318), one of the most important painters of fourteenth-century Italy, began to fuse Byzantine and Classical influences. Duccio's greatest work, the double-sided *Maestà* altarpiece (1308–11, *see* page 32) for Siena Cathedral, reveals a new naturalism, emphasizing delicately articulated figures who have more life-like proportions than had been seen previously.

In Florence, Cimabue (Cenni di Pepo, *c.* 1240–1302, *see* his *Madonna and Child Enthroned (Maesta of Santa Trinita, c.* 1290–1300), page 7), characterized as the first painter of 'modern' times, was interested in

using gradations of light and shade to depict three-dimensional space and forms. However, the most famous painter of the Proto-Renaissance period is Giotto di Bondone (1266–1337). His fidelity to the living world marks him out from all previous painters whose works survive. Giotto's new form of visual realism (the monumentality of his figures and his use of perspective) can be seen in his Scrovegni Chapel frescoes in Padua (c. 1305, *see* below and page 31), which commemorate his patron and tell the stories of the Virgin Mary and Jesus. His scenes remind us that beholders in this era saw a continuum between the sacred and the secular. They also emphasize human gestures in a wholly original way, increasing the emotional drama.

Some artists drifted from Giotto's naturalism in the middle of the fourteenth century, favouring a more formal art that echoed the ornamental Byzantine style. These changes may have been due to the Black Death and the tastes of individual patrons, but it is clear that the influence of Giotto continued into the early 1400s and that he played a key part in initiating a new phase in Italian painting.

Mosaic Art and Fresco Painting

The main types of art practised during the Proto-Renaissance period showed relatively little change from Romanesque times (c. 900–1200). They included mosaic and fresco painting. In the medium of mosaic, a painter provided a full-scale drawing for a glass specialist to translate into his medium. To piece together the image, the mosaicist used tiny squares of coloured glass called *tesserae*. These tesserae were set in a plaster ground and their individual surfaces set at irregular angles to catch and reflect candlelight in a shimmering way. However, mosaic gradually declined as an art form and was replaced by fresco painting, which offered greater realism to artists.

Fresco (literally 'fresh') is the process of painting on wet plaster. It was used to decorate large wall areas and ofen required artists to work above floor level on rickety scaffolding. The wall was carefully prepared by applying a layer of rough plaster, called *arriccio*, followed by a thin layer of wet plaster, called *intonaco*, which was trowelled on in sections. Working from a precise plan that sometimes involved drawing directly on to the plaster with a burnt-orange pigment called *sinopia*,

each section was quickly painted using pigments mixed with water that had to dry before a new section was started.

The work had to be done accurately, as there is no way to correct a fresco by painting over it due to the transparency of the colours. Each patch of wet plaster, called a *giornata* (day's work), overlapped the edge of the adjacent patch, with areas of complicated painting being relatively small. Most Italian fresco painters could manage an approximately life-sized figure in two days – one for the head and shoulders, the second for the rest. Frescoes could sometimes be painted on dry plaster surfaces (a technique called *fresco secco*) for fine details.

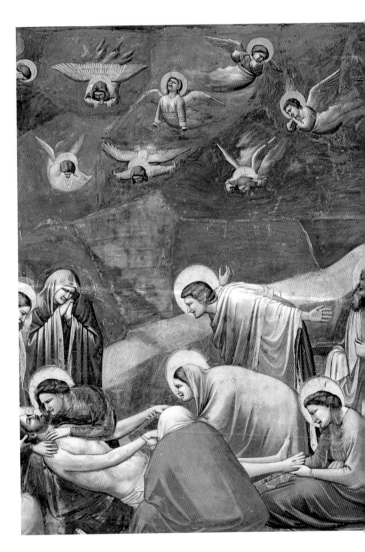

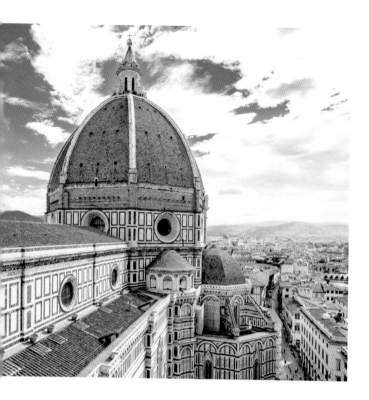

The Early Renaissance and Humanism

The fifteenth century (or *Quattrocento*) in Europe was a time of great changes in religion, ideas and behaviour, which were reflected in the work of great artists, especially in Italy. The main change, which became the basis of Renaissance thought, was a new understanding of man as 'centre and measure of all things'. It came into existence in slow stages through the revival of the literature of Classical antiquity (the texts of Plato, Aristotle, Virgil, Ovid and others) by poets and philosophers such as Francesco Petrarca (1304–74), called Petrarch in English, and Giovanni Boccaccio (1313–75). They had rediscovered the importance of the *studia humanitatis* (studies of humanity) – grammar, rhetoric (the art of speech-making), history, poetry and moral philosophy. Humanist was the name given to a person who received such an education.

It was in the fifteenth century that Italians in elite circles fully embraced the tenets underlying humanism, which included an emphasis on human dignity and potential, and the expansion of knowledge. The

adoption of this new philosophy was combined with the continuing hold of Christianity. Many Renaissance humanists saw no conflict between their study of the ancients and Christian theology.

Painters, sculptors and architects embarked on a revival of the artistic values of Classical Greece and Rome. In general, however, they aimed to do more than just copy from surviving Classical models: they wanted to surpass them and produce a work that was self-consciously new. The spread of humanism (it came to dominate life in the Italian peninsula and later much of Europe), economic prosperity and creative talent combined to nourish a significantly enlarged artistic culture.

It has been argued that this culture first bore fruit (and the Early Renaissance began) in Florence in 1401 with a guild-sponsored competition to decide who would be awarded the commission to create new bronze doors for the Baptistery of San Giovanni. The doors would contain panels representing scenes from the Old Testament, and seven sculptors were selected as semi-finalists to design a single panel showing the *Sacrifice of Isaac*. Only Lorenzo Ghiberti's (1378–1455) and Filippo Brunelleschi's (1377–1446) designs have survived, and both works reflect a humanistic and naturalistic Renaissance style. Ghiberti's submission, showing a muscular Isaac taken from Classical originals, won the competition, and it took him 27 years to complete the commission.

Brunelleschi: A Matter of Perspective

In his short but revolutionary treatise *De Pictura* (On Painting), first published in 1435, Leon Battista Alberti (1404–72) outlined in simple mathematical terms the principles of linear perspective, a technique that allowed forms to be depicted convincingly on a flat painted or sculpted surface through the use of orthogonal lines disappearing to a central vanishing point. Alberti seems to have relied extensively on the experiments of others when writing his book. First and foremost among these was his friend, the sculptor and architect Brunelleschi, who had completed the enormous masonry dome over Florence's Cathedral of Santa Maria del Fiore (*see* above, left). Brunelleschi's handling of the problems of space in the many buildings he executed had led him to devise a more scientific, concise and reliable manner of rendering

space on a panel. The importance of such a discovery hardly needs to be stressed. The representation of space, a key difficulty for a painter, has to be convincingly simulated if pictures are to be turned into windows on to worlds that seem real.

Brunelleschi's contemporaries not only credited him with the invention of linear perspective, they also praised him for his engineering skill and his revival of antique architectural forms. Having fled to Rome after losing the Baptistery door competition, Brunelleschi had studied both ancient buildings and the work of the Roman architect Vitruvius (c. 85–c. 20 BC), author of the influential *De Architectura* (*On Architecture*). Returning to Florence, Brunelleschi used his knowledge of Classical structures to work on the Cathedral dome, and projects such as the Pazzi Chapel and the churches of San Lorenzo and Santo Spirito. These were built using the ancient technique of rational proportions (creating a sense of harmony) and employed smooth lines, symmetrical arches, evenly spaced columns and Corinthian capitals. Brunelleschi married Classical styles with the Christian values existing in Florence at this time to create new spaces.

Constructing a building during the Renaissance was a collaborative process, involving teams of people (including carriers, masons and stone carvers) directed by an architect or master builder and – in the case of a public building – by the commissioning officials. When visualizing the design of a new building for a patron, an architect could either provide a presentation drawing (based on preliminary sketches) or a model of the planned structure (made from wood, stucco or clay).

Perspective: The Story Continues

Masaccio (Tommaso di Ser Giovanni di Simone, 1401–28) was one of the first painters in the Renaissance to use Brunelleschi's discovery of mathematical perspective in his art. He did this in his fresco of the *Holy Trinity* (c. 1427, see page 41) in the Florentine church of Santa Maria Novella. The proper perspective recession in the picture (the orthogonals can be seen in the barrel vaulted ceiling) used to create the illusion of space is striking. However, Masaccio's major achievement is his fresco cycle telling the story of the life of St Peter in the Brancacci Chapel of Santa Maria del Carmine in Florence (c.

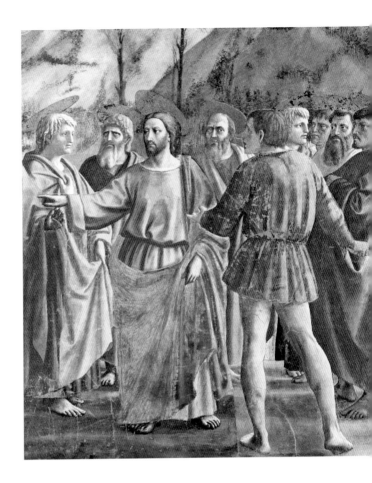

1425–27, *see* above and pages 37 and 38), which he worked on with Masolino da Panicale (c. 1383–c. 1447). It became a model for generations of later Florentine artists, including Michelangelo. Objects, faces, figures and drapery are all sculpted by light coming from what seems to be a single source, which Masaccio combined with a careful use of linear perspective to give an impression of believable forms in space.

Paolo Uccello (Paolo di Dono, 1397–1475) was also obsessed with the problems of perspective and representing solids in space, as seen in works such as *The Battle of San Romano* (*see* page 48), a set of three panels commissioned between 1435 and 1460, and *The Flood* (1447), a fresco painted as a lunette in the cloister of Santa Maria Novella in Florence. Uccello rendered every element of his compositions with scientific precision to enhance expression. His fascination with

geometrical puzzles was typical of fifteenth-century artists. For example, Piero della Francesca (*c.* 1415–92) devoted much of his intellectual energy to them. He composed treatises on geometry and perspective, and he was a mathematical theorist. This interest is reflected in the defined volume of figures and accurate perspective in his works, including *The Baptism of Christ* (1450, *see* below and page 53), which seems to be based on a grid of three equidistant horizontals and four verticals.

Realism, linear perspective, novel compositional designs and a vocabulary of antique forms were all further developed and refined by the next generation of Renaissance artists. These included Antonio del Pollaiuolo (*c.* 1432–98), known for his paintings, sculptures and engraving designs, and Andrea Mantegna (*c.* 1431–1506), who worked in Padua, Verona and Venice before becoming court artist to the Gonzaga family in Mantua, where the medallist and painter Pisanello (Antonio Pisano, *c.* 1395–*c.* 1455) had earlier been employed.

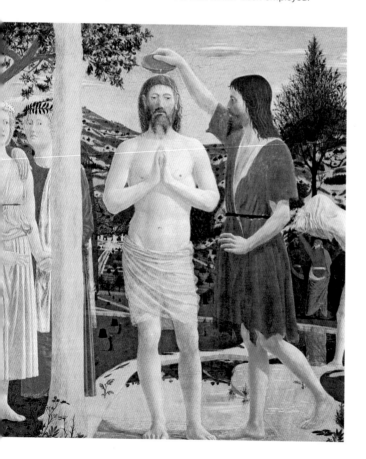

Donatello and Bronze Sculpture

Donatello (Donato di Niccolo di Betto Bardi, 1386–1466) had first displayed his command of scientific linear perspective in his dramatic bronze relief panel with an architectural background, *The Feast of Herod* (*c.* 1427), for the baptismal font of San Giovanni in Siena. However, the Renaissance revival of Classical values in the arts was not limited to the use of perspectival systems. It included the revival of the freestanding nude statue as well. Donatello was the first Renaissance sculptor to represent the nude male figure in his bronze *David* (1460–65). Modelling Christian subject matter (the theme of David and Goliath was a popular one) on a sensuous Classical sculptural type, Donatello was very aware of the special qualities of his medium in terms of attracting the light and generating a multitude of reflections.

The process of casting a bronze was difficult, time-consuming and expensive. Donatello, like many sculptors, appears to have left it to specialist founders (professionals, such as makers of bells or cannons). The majority of Italian sculptors opted to make small bronzes using the 'direct' lost-wax technique. This method involved preparing a wax model over a clay and metal core that was heated in a furnace, and eventually replacing the wax with molten metal to create the finished artwork. The bronze surface would be worked with tools ('chased') and polished to the required level of finish.

The Angelic Painter

The fifteenth century was a time of reform movements in the Church primarily led by ascetic monks and friars who made the rules of their orders more stringent and urged the laity to more intense devotion. It culminated in the 1490s with Girolamo Savonarola (1452–98), the Dominican preacher who condemned the corrupt clergy and the rulers of the day, including their artists, poets and philosophers, in a spirit of rigid puritanism. However, before Savonarola, a new, spiritually stimulating and contemplative tone had emerged in Italian religious painting, embodied in the serene yet classically inspired art of Fra Angelico, born Guido di Pietro (*c.* 1395–1455).

One of the principal painters of the Early Renaissance, Fra Angelico pioneered the use of realism and the impression of volume to define figures, as well as linear perspective. Much of his work was created for the Dominican friary at Fiesole and the friary of San Marco in Florence (*see* pages 46 and 47), where, with some assistants, he frescoed the cloister walls, the chapter house, the corridor on the upper floor and the cells (the rooms where the friars spent their lives, reading, praying and sleeping). According to Vasari, Fra Angelico was a man of such deep and honest faith that he said a prayer every time he took up his brush and wept every time he painted a crucifix.

Powerful Patrons: Botticelli and the Medici

The practice of patronage during the Renaissance showed varied objectives. Underlying the phenomenon, political, cultural, aesthetic and religious considerations can be found. Patrons included individuals (from princes to well-to-do citizens) as well as larger organizations such as town councils. It was the taste and desires of these patrons that were meant to be expressed in the appearance of the art they commissioned.

The Medici family of Florence offer an example of how calculated spending enhanced and furthered family fortunes and self-identity. The Medici rose to prominence in the fifteenth century and effectively dominated Florentine political affairs. Initially trading in textiles, it was through their banking that they amassed enormous wealth and an international profile that was bolstered by the lavish artworks they commissioned. This tradition of visible expenditure was initiated by Cosimo de' Medici (1389–1464), and referred to as 'magnificence' by his approving contemporaries. Cosimo's son Piero (1416–69) and grandson Lorenzo (1449–92) followed in his footsteps, developing Medici patronage into an extravagant dynastic display. Exiled from Florence in the years 1494–1512 and 1528–30, the family's inexorable political and social rise was only temporarily disrupted.

The patronage of Lorenzo de' Medici ranged far and wide, but one of his favourite painters was Sandro Botticelli (1445–1510). Botticelli had completed his apprenticeship in the workshop of Fra Filippo Lippi (c. 1406–69), who was known as much for his unconventional

life as his expressive effects. Botticelli produced numerous paintings with Medici themes in the 1480s and early 1490s, including life-size mythological works such as *Primavera* (c. 1478, *see* page 77) and *The Birth of Venus* (c. 1485, *see* page 80). These compositions, possibly commissioned by Lorenzo di Pierfrancesco de' Medici (1463–1503), head of the junior Medici line, combine a decorative use of line with a balanced, graceful style and delicate colours.

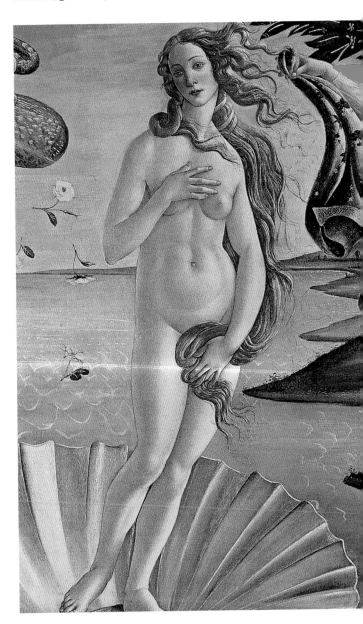

Although mythological figures had been used in earlier, secular Renaissance works, it was in the elite context of Medici patronage that a new mythological language in art became current. This was inspired by the humanist interest in Classical literature and the ideas present in the group of Florentine Neoplatonists, who attempted to blend Christian doctrine with Platonic philosophy in a mystical system. There can be little doubt that Botticelli's approach was also influenced by the world of poetry. Angelo Poliziano (1454–94), a scholar at the Medici court, encouraged Botticelli to make his works appear like visual poems.

Oil Painting

The Medici traded in all the major European cities, and one of the most famous masterpieces of Northern Renaissance art, the *Portinari Altarpiece* (*c.* 1477–78, *see* below), by the Flemish painter Hugo van der Goes (*c.* 1440–82), was commissioned by their agent, Tommaso Portinari (1428–1501). A notable aspect of this work is that instead of being painted with the customary tempera, translucent oil glazes were used.

From as early as the tenth century, various oils had occasionally been used to bind powdered pigments. However, it was not until the early fifteenth century in Flanders that artists began to exploit the potentialities of pigments mixed with oil (usually linseed or walnut) in applying successive layers of paint over colours to give an appearance of depth. Using oil, a malleable substance that dries slowly, a painter could blend with a freedom impossible with tempera, and quickly make hundreds of changes or adjustments to the composition of a picture during the painting process. Not only could a work now be left for days and then resumed with ease, the effect of light playing over the glazes resulted in ever more naturalistic effects.

The 'invention' of oil painting was long ascribed to Jan van Eyck (*c.* 1390–1441), whose skill in using the technique can be seen in the dazzling, jewel-like quality of his picture surfaces. The catalyst for this change of medium in Italy was, according to Vasari (but disputed by modern scholars), the visit to Venice in 1475–76 of Antonello da Messina (*c.* 1430–79), a Sicilian painter who had travelled north to Flanders to learn Jan van Eyck's method of oil painting. His use of oils allowed him to make works with miniaturist detail, controlled variations of tone and luminous colour.

Giovanni Bellini

In Venice, the leading figures of the Early Renaissance included Jacopo Bellini (*c.* 1400–70), a student of Gentile da Fabriano (*c.* 1370–1427), and his sons Gentile Bellini (*c.* 1429–1507) and Giovanni Bellini (*c.* 1430–1516). Giovanni was a major pioneer of oil painting in Venice, and his assimilation of the technical and stylistic innovations of the period saw him became one of the most influential Venetian artists.

Venice's political and trading connections in the East meant that its cultural orientation was very different from that of Florence or Rome. The local artistic tradition favoured the sensual Eastern values, focusing on colour, texture and surface rather than intellectualized forms (an approach similar to that of painters working in Flanders and Germany). It was only from the middle of the fifteenth century onwards that there was a shift towards illusionistic naturalism, with Venetian artists responding to developments in Florence.

Giovanni Bellini's *San Giobbe Altarpiece* (*c.* 1487, *see* page 69) makes visible this change. Moving away from his earlier style (that had been heavily shaped by his brother-in-law Mantegna) to a more mature, independent and versatile approach, Giovanni's mastery of linear perspective, drawn from Alberti's directives to painters, is clear. However, it is his portrayal of natural light, reliant on his handling of oil paint, which is really groundbreaking. Perhaps influenced by Antonello da Messina's visit to Venice, Giovanni used oils to bind figures, objects and spaces together to produce a sense of monumentality and convey a new depth of feeling, and his colours took on an added richness and range.

Printmaking

A significant technical artistic innovation during the fifteenth century was the print. The technology of printmaking made it possible to rapidly disseminate images over a geographically wide area. This invention was followed by the introduction of movable type, pioneered by the German goldsmith and printer Johannes Gutenberg (*c.* 1400–68). This meant the first printed books and pamphlets could be produced, facilitating the spread of knowledge in areas such as the sciences, anatomy and the art of engineering.

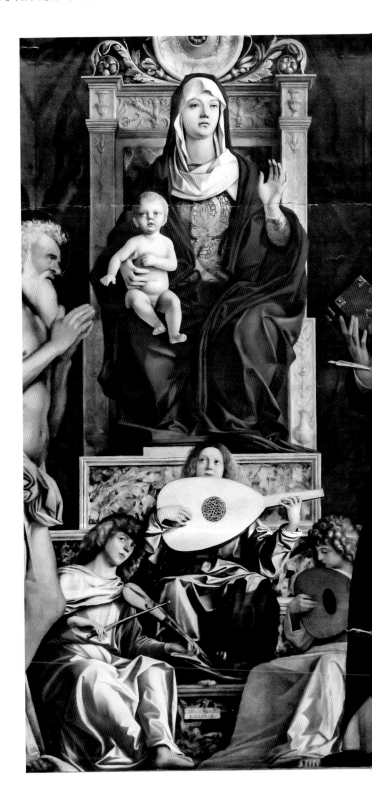

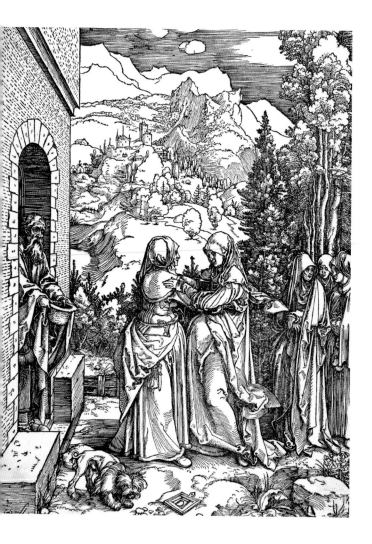

Engraving is the practice of making prints from metal plates. On a copper plate the artist drew the design, then engraved the lines with a burin, a special pointed tool. The plate was then covered with a thick black ink, which would be pushed into the incised grooves and the excess wiped away. Linen-rag paper was placed on the inked plate and both paper and plate were run through a press, again producing a reverse image. In both woodcut and engraving the plates could be used repeatedly until the pressure of the printing press caused them to wear and break.

Print provided a new outlet for artists to explore their own interests, and it enabled them to reach a much larger audience than they could with their private commissions. Woodcuts and engravings publicized the inventions of painters, their technical proficiency and skill, and promoted new meanings and stylistic ideas.

The High Renaissance

The period from the 1490s to 1527 is commonly known as the High Renaissance, the time when earlier techniques and Classical ideals are deemed to have reached their greatest application. However, in recent years the use of the term has been criticized by art historians for oversimplifying artistic developments and ignoring the historical context and eclectic visual culture of the day. Describing an artwork as 'high' suggests that it is better than anything produced before or since. It is necessary to be sceptical about any such evaluation, as it relies on debatable ideas about what constitutes great art. 'High Renaissance' can be a useful label for referring to a cultural movement, but it has to be employed with caution.

The first quarter of the sixteenth century was one of political strife and nearly constant warfare in Italy. In Florence, the century opened with the Medici family banished from the city (they returned in 1512). Northern Italy was invaded by the French (Milan was occupied twice) and in Rome the papacy was engaged in extending and asserting its spiritual and temporal power. Pope Julius II (Giuliano della Rovere, 1443–1513) was almost continuously leading his troops on military campaigns (he was nicknamed the 'Warrior Pope'). Both he and his successor, Pope Leo X (Giovanni de' Medici, 1475–1521), imported leading artists from Florence and elsewhere to get their message across.

During the Renaissance, the two most widely used printmaking techniques were the woodblock print and engraving, both of which came to prominence in Italy in the 1470s. In the former, the image was drawn on a smooth piece of wood. The artist would then, using a chisel, carve away parts of the surface of the wood, leaving the drawn lines standing in relief. These raised areas were inked, moist paper applied and the block printed, giving a reverse of the block's image on the paper. The German painter and printmaker Albrecht Dürer's (1471–1528) woodcuts on religious subjects – including the *Life of the Virgin* (*c.* 1501–11, *see The Visitation*, 1503, above) – are outstanding examples of this technique and elevated printmaking to the level of an independent art form.

However, the main event of the period was the movement for religious reform. The rebellion against the Catholic Church, its teachings and practices, known as the Protestant Reformation, was led by charismatic figures such as Martin Luther (1483–1546). In 1517, Luther nailed his 95 theses (or complaints) to the door of Wittenberg Cathedral and signalled a radical break in European religious life, calling into question the traditions and assumptions underlying society, including the visual arts. The era ended in 1527 when Rome itself was sacked by Charles V's German and Spanish mercenaries. Yet it was during this turbulent period that the art of the High Renaissance came into being.

A new generation of Italian artists, dominated by Leonardo da Vinci (1452–1519), Michelangelo and Raphael (Raffaello Sanzio, 1483–1520), brought together close study of the physical world, mainly Christian subject matter, a full awareness of the Classical past and an emphasis on originality. Indebted to fifteenth-century figures such as Masaccio and Donatello, a newly ambitious art emerged.

Leonardo: Scientist and Artist

The high position given to Leonardo is remarkable given the small number of works he completed. In fact, very few artists drew as much and painted as little as Leonardo. No more than 15 paintings and one fresco have survived, while his drawings of human anatomy (based on living models and dissections of dead ones), mechanical contrivances and natural phenomena are very numerous indeed. It is clear from the notebooks Leonardo wrote that he viewed art as an investigative science that he could use to increase his understanding and knowledge of nature.

Leonardo trained as a painter and sculptor in the Florentine studio of Andrea del Verrocchio (c. 1435–88), and legend has it that Verrocchio modelled his bronze statue of the young *David* (1473–75) on his handsome new assistant. In Verrocchio's workshop Leonardo studied metalwork, the human form, plants, animals and optics, but his proto-scientific approach may have been partly inspired by the detail-oriented fifteenth-century paintings of Northern Europe.

Leonardo was well aware of familiar themes in fifteenth-century Italian art. His devotional images and altarpieces recall earlier examples. This is true of his famous *Last Supper* in the refectory of Santa Maria delle Grazie in Milan (c. 1495–98, *see* page 90). Rather than use the usual fresco, Leonardo covered the wall with a double layer of dried plaster and an undercoat of lead white, with oil and tempera on top, to disastrous results. Soon after it was finished, the paint started to peel from the wall. However, Leonardo invested the scene with a

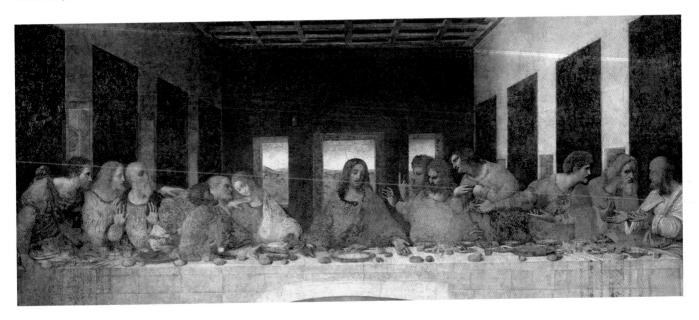

new animation. He used orthogonals to create a sense of depth and the picture's lighting aligns with the actual windows in the room.

The psychological overtones in the *Last Supper* can also be found in Leonardo's best-known painting of all, the *Mona Lisa* (c. 1503–05, *see* page 94), which began as a typical society portrait

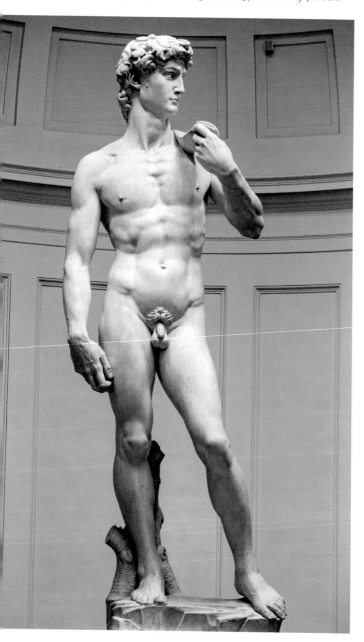

and has become an icon of the Renaissance. Leonardo used his characteristic *sfumato* technique (softly blending colour tones into one another to create a misty, atmospheric effect), *chiaroscuro* (modulating light and dark to model forms) and aerial perspective, calling attention to the work's mystery and harmony.

Michelangelo and Marble

Leonardo's and Michelangelo's careers overlapped at various points, especially in the first decade of the sixteenth century. Apparently the two artists, who both worked in Florence's town hall in 1504–05, developed an 'intense dislike' for one another. They were on different sides in the *paragone* ('comparison') debate; in his notebooks, Leonardo tried to prove that painting was superior to sculpture, while Michelangelo favoured sculpture to any other medium, and initially refused to paint the ceiling of the Sistine Chapel in Rome because he had originally come to the city to make a free-standing tomb for Pope Julius II.

Michelangelo began his career as an apprentice to the painter Domenico Ghirlandaio (Domenico Bigordi, 1448–94), famed for his narrative frescoes and portraits. (Later in life Michelangelo claimed to be entirely self-taught.) It was Michelangelo's statue of *David* (1501–03), which earned him the respect and patronage of Pope Julius II, and their 10-year partnership was a meeting of minds and a war of egos. Michelangelo's colossal *David*, a figure of perfect anatomy, showing a deep understanding of the sculpture of Classical antiquity, is a technical triumph. It was carved from a narrow block of marble ruined and abandoned by other sculptors.

Such was Michelangelo's involvement with the blocks of marble from which his statues would emerge that he often made the journey to the marble quarries of Carrara, the best in Italy, to select for himself marble from the mountainside. On one occasion, he remained eight months to select 40 marble blocks for a project.

Although Michelangelo did much of the laborious work of marble carving himself, stone sculpture was often a collaborative endeavour. It presented unique challenges, starting with the

expense and logistical difficulties of transporting heavy material. Engineering ability was needed to construct the rigging to position large blocks. The stone had to be shipped, requiring travel by boat and oxcart. When the stone arrived at the workshop, assistants blocked out the figure by transferring points from a small wax or terracotta model, or by following drawings made by the master or a rough design sketched directly on the stone. The sculptor would work in from the stone block, refining the form by using drills and pointed chisels, progressing to chisels with finer cutting edges as the carving became more delicate. The stone would then be smoothed using files and abrasives such as pumice, and polished with straw and cloth.

Bramante's Tempietto

Like Michelangelo, the architect Donato Bramante (1444–1514) worked in the papal service, and the impressive buildings he produced, with their Classical forms recalling the greatness of ancient Rome, speak of the newfound power and ambition of the papacy. In 1502, Bramante built the Tempietto (see right) in the courtyard of the church of San Pietro in Montorio in Rome, on the spot where Saint Peter was thought to have been crucified. Influenced by Brunelleschi and Alberti, Bramante's minute temple attempted to fuse Christian and humanist beliefs, combining the traditional circular form of Early Christian commemorative chapels with antique Roman models. Surrounded by a colonnade of equally spaced Doric columns bearing the entablature and the dome's drum, the building symbolized the concentric cosmos and reflected celestial harmony in its proportions and pure geometric forms. Pope Julius II, looking at Bramante's temple, understood its implications and realized the importance of an artist like Bramante for giving expression to his ideology.

It was Bramante's sympathy with ancient Rome that led Julius to entrust to him the rebuilding of the basilica of Saint Peter's, and Bramante designed the most grandiose centralized church he could conceive. Although the basilica was not to be built to his design, he had, nevertheless, set a new standard of solemn grandeur in High Renaissance architecture.

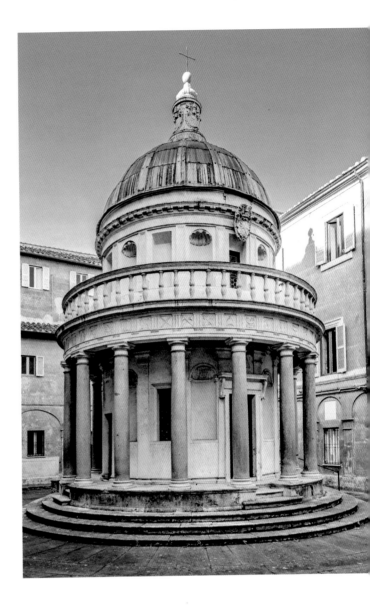

Raphael in Rome

Bramante was artistic adviser as well as architect to Pope Julius II and he may have been responsible for engaging Raphael to decorate the Pope's private apartments in the Vatican. More versatile than Michelangelo and more prolific than Leonardo, Raphael was greatly influenced by the rich colours and idealized faces of Pietro Perugino (Pietro Vanucci, c. 1446–1523), with whom he worked before becoming an independent master, and the sense of space

and proportions of Piero della Francesca. In Florence, he assiduously studied the art of both Leonardo and Michelangelo, and became a noted portraitist and painter of Madonnas (*see* page 96, *Madonna of the Meadow*).

Raphael arrived in Rome in 1508 to work on frescoes in the suite of papal offices known simply as *le stanze* (the rooms), and the Stanza della Segnatura, a library, came first (1509–11). Despite having little experience of fresco or handling large-scale figure groups, Raphael's decoration was perhaps his greatest work. The paintings allude to the four branches of humanist learning – Theology, Poetry, Philosophy

and Jurisprudence. The fresco illustrating Philosophy, marked by its contrasts in colour, is generally entitled *The School of Athens* (*see* below and page 105) and features ancient Greek thinkers, mathematicians and scientists gathered together in an architectural setting, sharing their ideas and learning. In the very centre are Plato and Aristotle (whose different philosophies were incorporated into Christianity). They are surrounded by figures such as Pythagoras, Ptolemy and the brooding Heraclitus. The last, inserted as an afterthought, is possibly a portrait of Michelangelo.

Raphael's supremely eloquent and Classical style (which was readily copied by later artists) tapped into Rome's very particular cultural rhetoric and Pope Julius II's dream of making Rome the capital of a new Christian Roman Empire. It was not unusual for popes Julius II and Leo X to assert, almost obsessively, that they were presiding over a new Golden Age.

Drawings

During the Renaissance, drawings played a vital role in art. Vasari noted the importance of drawing – or *disegno* – in Central Italian, especially Florentine, art, giving the word a complex meaning, involving both the ability to make the preparatory study and the intellectual capacity to conceive the design. A long-lived debate about the relative merits of *disegno* and *colorito* or 'colouring' (where colour is employed as a dominant compositional element), involved theorists as well as artists, and regional rivalries as well as aesthetic concerns.

Michelangelo, Leonardo and Raphael made drawing central to their artistic practice, building on a trend that had started to gain momentum in mid-fifteenth-century Italy with the *spolvero*. The *spolvero* (Italian for 'dust off') was a full-scale drawing of a complicated detail. The outlines of the drawing were pricked with a sharp point and, after the drawing was placed on the painting's surface, it was tapped with a sponge loaded with charcoal dust, transferring rows of dots outlining the design. In the early sixteenth century, the *spolvero* was replaced by drawings known as cartoons (from the Italian word for heavy-weight paper, *cartone*). The cartoon was pressed against the surface to be painted and its outlines were transferred by the use of a metal point. Many cartoons survive,

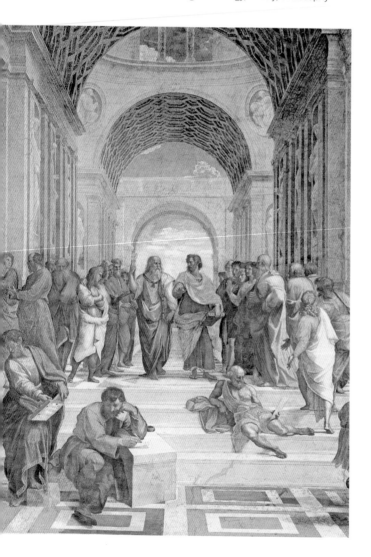

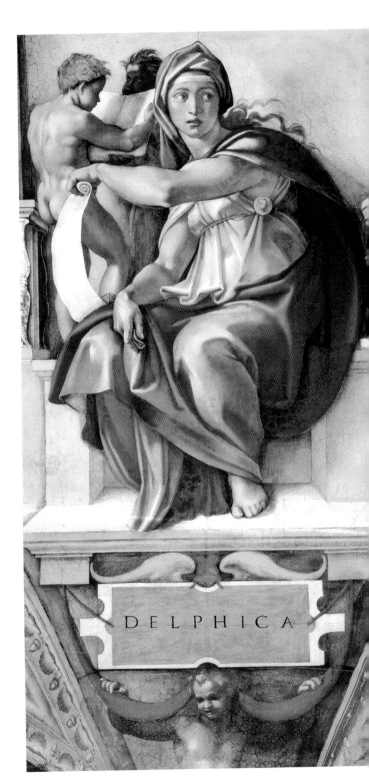

indicating the diversity of media (silverpoint, pen and ink, chalk) and drawing styles employed by Renaissance artists. These range from Leonardo's drawings precisely studying light as it falls on drapery to Raphael's drawings, showing his use of quick strokes to capture naturalistic movement and his responses to contemporary works by Leonardo and Michelangelo.

The availability of relatively cheap paper (a by-product of the advent of the printing presses) increased the number (and scope) of preparatory studies an artist could use. Throughout the Early Renaissance period drawings seem to have served a functional role (they were tied to the workshop, where they could be used to train assistants). However, at the beginning of the sixteenth century, patrons, desperate to get their hands on the work of important artists, seemed satisfied to have a drawing by a particular artist. Many carefully finished presentation drawings on coloured paper (often representing nearly nude figures) were meant to convince the patron of the artist's abilities by their visual magnificence.

A Legendary Ceiling

While Raphael was painting the Stanza della Segnatura, Michelangelo was toiling away on the Sistine Chapel ceiling frescoes (1508–12, *see* right and pages 99–104) for Pope Julius II, replacing a blue ceiling dotted with stars. Michelangelo's design of the ceiling referenced antique painting and the Arch of Constantine (AD 315), but also a range of predecessors and contemporaries such as Pinturicchio (Bernardino di Betto, 1454–1513), Perugino and Bramante.

Michelangelo conceived the ceiling as an imaginary architectural structure and divided the Old Testament scenes on the vault into three sections. In the first three paintings, Michelangelo tells the story of *The Creation of the Heavens and Earth*; this is followed by *The Creation of Adam and Eve* (the most famous of the frescoes) and the *Expulsion from the Garden of Eden*; ending with the story of *Noah and the Great Flood*. Beneath the fictive architecture painted in *grisalle* (a greyish, monochromatic colouring), sit *ignudi*, or nude youths. They are accompanied by figures of the prophets and pagan sibyls (ancient seers who, according to tradition, foretold the

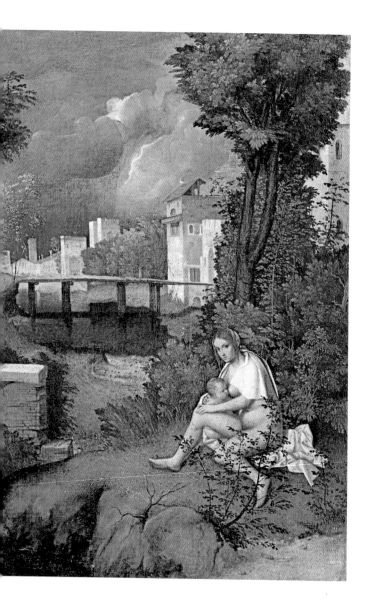

coming of Jesus) in the spandrels (*see* page 104), which some art historians believe are based on the *Belvedere Torso*, an ancient sculpture (first century BC). Michelangelo's dramatic positioning of both monumental and foreshortened figures, and his vibrant palette of yellows, acid pinks and sharp greens, convey a strong sense of emotionality.

Michelangelo often complained bitterly about his lack of payment, droplets of paint falling into his eyes and physical exhaustion as he

worked on the ceiling. Painting at a height of 20 metres (65 feet) on scaffolds and platforms slotted into specially made wall openings, he worked on the vault of the chapel standing up, but was forced to crane his neck at an angle, causing him painful spasms and headaches. 'My beard toward Heaven, I feel the back of my brain upon my neck,' he wrote in a comical poem for a friend. However difficult the conditions, Michelangelo succeeded in creating some of the most important and powerful images in the world, which have inspired generations of artists.

Vasari Strikes Again

Much of our contemporary picture of 'the artist' as a misunderstood, heroic genius is based on nineteenth-century romantic stereotypes, as it was in this period that emphasis shifted from an artist's skill to their creativity and personal traits. However, some aspects of this conception of the artist can be dated back to the Renaissance. Although the vast majority of artists made no special claim to greatness and were still seen as artisans, figures such as Michelangelo became 'superstars', whose fame and influence were international and whose patrons included popes, emperors and princes.

Organized as a chronological series of biographies that discussed each artist as an individual creative genius, Vasari's *Lives of the Most Excellent Painters, Sculptors, and Architects* developed the 'great man' approach to art history that continues to inform many of our most firmly held assumptions about artists and art to this day. Vasari fostered the idea that leading painters were extraordinary and possessed talents that were God-given rather than learned. In fact, he dubbed the multi-talented, melancholic and tempestuous Michelangelo 'the Divine One' (*Il Divino*).

In reality, artists' reputations became a more complicated phenomenon during the Renaissance, as the relationship between their cultural status and their social status was always in flux. That said, artists in Italy enjoyed higher esteem than artists elsewhere. That at least, was the impression of Dürer as he prepared to leave Venice for Germany in late 1506: 'Here I am a gentleman, at home only a parasite.'

The High and Later Renaissance in Venice

Giorgione (Giorgio da Castelfranco, *c.* 1478–1510), the first great Venetian High Renaissance painter, exploited the effects of the new Venetian method of painting on canvas (rather than panel) with pigments mixed with oils. One of his best-known pictures is *The Tempest* (*c.* 1506–08, *see* opposite). Depicting a landscape whose colours are transformed by the arrival of a storm and a flash of lightning, the picture is typical of the artist in its small scale, loose handling of paint, atmospheric subtlety (Giorgione, following Leonardo, used *sfumato*) and ambiguous meaning.

By the 1520s, Titian (Tiziano Vecellio, 1488–1576) was the foremost painter in Venice. Establishing his artistic standing in the dynamic *Assumption of the Virgin* altarpiece (1516–18, *see* page 110), Titian's wider fame rested on his aristocratic portraiture. However, it is his erotic painting of a reclining female nude, the so-called *Venus of Urbino* (1538, *see* page 117), that is one of the most famous images of the Renaissance. Titian's later reputation was based on his relationship with the Emperor Charles V (1500–58), for whom he painted portraits and mythologies (*see* page 115, *Portrait of Charles V with a Dog*). Charles made Titian Count Palatine and endowed him with a yearly income, which his son Philip II of Spain (1527–98) increased. It was for Philip that Titian painted six *poesie* (mythological works), including *The Rape of Europa* (1560–62, *see* page 121), illustrating his use of colour and animation of the picture surface by contrasting *impasto* (thick paint layers) with thinly applied brush marks.

With Titian working mainly for Philip II, Venetian public commissions went to younger painters, notably Tintoretto (Jacopo Robusti, 1518–94) and Veronese (Paolo Caliari, 1528–88). Tintoretto reputedly began in Titian's studio. An intensely religious artist, his works are full of irrational perspective effects, violent foreshortening, gesticulating figures, expressive colour and unnatural light, as seen in his decoration of the Scuola di San Rocco (1565–88) in Venice (*see* above and page 122, *The Crucifixion*). Veronese, celebrated for his lush brushwork, shimmering fabric effects and theatrical scenes, is renowned for

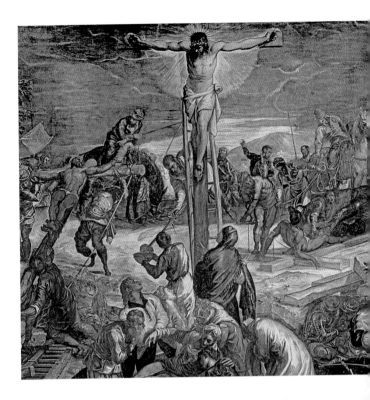

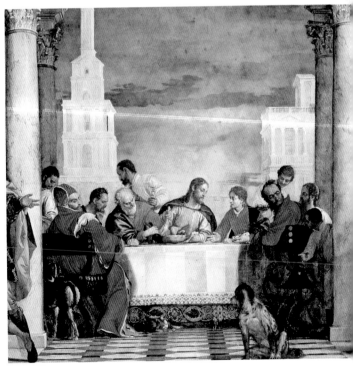

having avoided the charges of heresy levelled against him by the Inquisition for his painting for Santi Giovanni e Paolo in Venice. The picture, a depiction of the Last Supper, was deemed by judges to be inappropriate on account of the dogs, buffoons and drunken figures in it. Veronese's solution was to change the painting's title to *Feast in the House of Levi* (1573, *see* above and page 124).

Mannerism

Italy in the 1530s and 1540s underwent a traumatic upheaval. In addition to the Protestant Reformation and the Catholic Church's response (the Council of Trent opened in 1545 and reaffirmed traditional doctrines; it was followed by a period of so-called Counter-Reformation), things had taken a turn in another direction when Nicolaus Copernicus (1473–1543) formulated his theory that the Sun and not the Earth was at the centre of the universe. Some one hundred years later, Galileo Galilei (1564–1642) would be forced to recant his belief in this heliocentric world picture.

Reflecting the darker mood pervading Rome after the devastating Sack, Michelangelo worked for the dying Clement VII (Giulio de' Medici, 1478–1534) and the new pope, Paul III (Alessandro Farnese, 1468–1549), painting the altar wall of the Sistine Chapel with a scene of the *Last Judgement* (1534–41, *see* page 107). Depicting the Second Coming of Christ and the resurrection of the dead, who are raised up to Heaven or cast down to Hell, human forms are suspended in a single plane and stripped back to their raw essentials. Pessimism and punishment take centre stage.

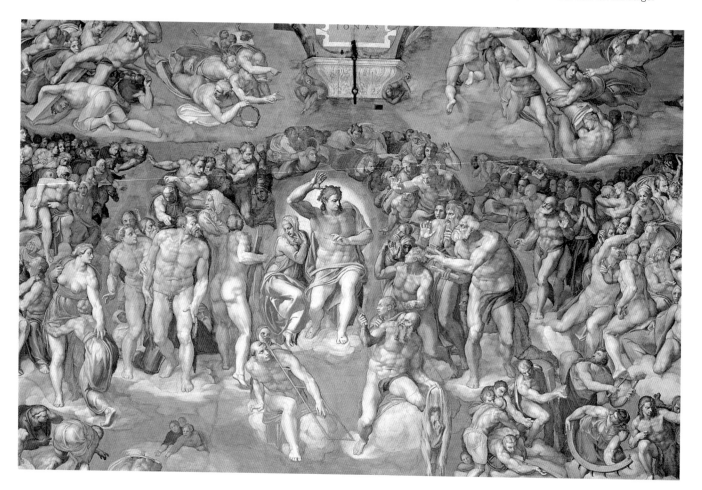

It was in this context that Mannerism arose. Derived from the Italian *maniera*, meaning 'style', Mannerism (which lasted from the 1520s to 1600) is sometimes defined as the 'stylish style' for its emphasis on self-conscious artifice over realistic depiction, and for prizing virtuosity and refinement. Qualities associated with Mannerist art include elongated proportions, twisting poses, a flattening of pictorial space, sharp acid colours, emotionalism and bizarre lighting effects.

The character of Mannerism continues to be debated. It is often judged in relation to the High Renaissance. Some scholars see Mannerism as a reaction to High Renaissance Classicism, while others regard it as an extension of it – a logical continuation of elements found in late works by Michelangelo and Raphael. In the seventeenth century, most critics thought Mannerism marked a sharp decline from the peaks reached during the High Renaissance, with artists reduced to slavishly copying the work of past masters. More recently, however, a more sympathetic approach towards Mannerism and its intellectual sophistication has emerged.

Florentine Masters of Mannerism

Andrea del Sarto (1486–1530) could be called the godfather of Mannerism. His use of vibrant colour and complex poses inspired the first generation of Florentine Mannerist artists, which included two of his pupils, Pontormo (Jacopo Carucci, 1494–1557) and Rosso Fiorentino (Giovanni Battista di Jacopo, 1495–1540). Their strange paintings are full of restless movement, psychic energy, ambiguous space, vivid colours and an intense spirituality, as can be seen in Pontormo's *Deposition* (1525–28, *see* right) for the Capponi chapel in the Florentine church of Santa Felicità.

Under the influence of Michelangelo, Pontormo's figures developed a more distinct sculptural presence. Essential to the culture of art in the mid-sixteenth century was the focus on the depiction of the nude human body. In Italy, the study of anatomy became officially acknowledged as a necessary part of an artist's training. Andreas Vesalius's (1514–64) *De humani corporis fabrica* (*On the fabric of the human body*, 1543) was the first comprehensive illustrated textbook of anatomy based on

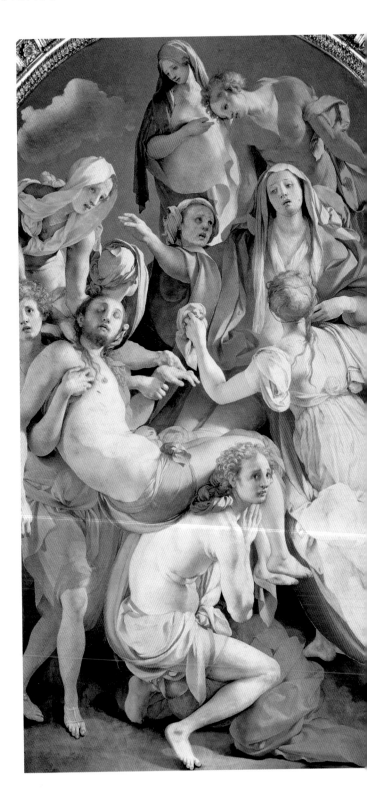

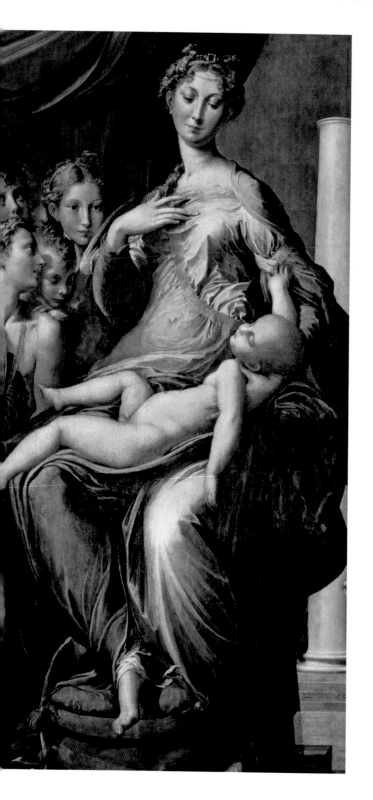

dissections, and it gained importance for painters and sculptors. They used it in their studio practice and to further their own scientific interests.

By 1540, Pontormo's student Bronzino (Agnolo di Cosimo, 1503–72) was the leading Mannerist artist in Florence and court painter to Cosimo I de' Medici (1519–74), grand duke of Tuscany. Bronzino's precisely linear style is demonstrated in his elegant, decorative but emotionally inexpressive official portraits of Cosimo I, his wife Eleonora of Toledo and their children (*see* page 119, *Portrait of Eleonora of Toledo with Her Son Giovanni*). The refined artificiality associated with Mannerism can be best appreciated in Bronzino's sensual *Allegory with Venus and Cupid* (*c.* 1545, *see* page 118), painted for the French King Francis I (1494–1547), although its meaning continues to baffle art historians.

Mannerism in Northern Italy

By the mid-sixteenth century, the influence of Mannerism had spread far beyond Florence. An important representative of the movement in northern Italy was Correggio (Antonio Allegri, 1489–1534). In his illusionistic fresco of the *Assumption of the Virgin* (1526–30, *see* page 111) in the dome of Parma Cathedral, Correggio created a vision of figures with fluttering drapery swirling up into the heavens. Though it is an influential work, Correggio's skill in depicting figures seen from below was not appreciated by everyone – one eighteenth-century observer grumbled that the piece was a 'frog leg stew'! In his sensuous mythological paintings of the early 1530s showing the *Loves of Jupiter* – including Io (*see* page 113) – Correggio drew on Leonardo's art to create images of extreme softness (*morbidezza*).

The early career of Parmigianino (Girolamo Francesco Maria Mazzola, 1503–40) was heavily influenced by Correggio, but in paintings such as the *Madonna of the Long Neck* (1535–40, *see* left and page 116) he went further, pursuing grace to extremes, as not only the Virgin's neck, but her hands, fingers and legs are all elongated and the spatial composition is unusual. This principle of distorting the ideal human figure as a means of heightening expressiveness and arousing religious fervour was taken up by El

Greco (Domenicos Theotocopoulos, 1541–1614) at the end of the sixteenth century. The religious works of Lavinia Fontana (1552–1614), one of the first professional women artists, display influences from both Correggio and Parmigianino. Her portraits are reminiscent of the work of another female painter, Sofonisba Anguissola (1532–1625), but they also exemplify the Mannerist style.

In architecture, Mannerism shaped Palladio's (Andrea di Pietro della Gondola, 1508–80) designs for palaces and villas, notably the *Villa Rotunda* (1550–51, *see* below) near Vicenza. It combines the mathematical theories of the Renaissance with ancient Roman models to forge an innovative construction emphasizing balance, visual clarity and uniformity. Palladio's international fame was assured by his 1570 treatise *I quattro libri dell'architettura* (The Four Books of Architecture) and his Roman-inspired auditorium the Teatro Olimpico (1580–85).

The Renaissance Legacy

All of the examples discussed here indicate, to some extent, why we should not make too strong a distinction between the Renaissance and the Medieval period that preceded it, or between the 'sacred' and 'secular' in Renaissance art. Similarly, the principles of ancient Greek and Roman art co-existed with technical innovation. We have also seen that the rising status of artists and the increasing value placed on artistic ingenuity in this period ran alongside the considerable influence and power of patrons.

Evolving from the Classical forms of the Renaissance, the art of the Baroque period of the seventeenth and early eighteenth centuries would go on to embody a dynamic energy, characterized by overt emotion, opulent colour and dramatic images of faith, driven by the Catholic Counter-Reformation. However, it was in the tumultuous Renaissance era that the seeds of the modern world were sown and the boundaries of human knowledge were pushed, instituting the new closeness of art to science, poetry and philosophy. As this book reveals, from the discovery of the solar system to the beauty of Michelangelo's Sistine Chapel ceiling, the Renaissance changed the world in just about every way imaginable. For this reason, it is unsurprising that today we still stare transfixed at the art of the Renaissance.

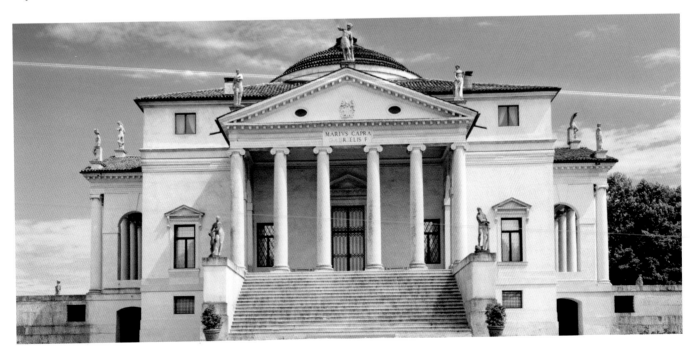

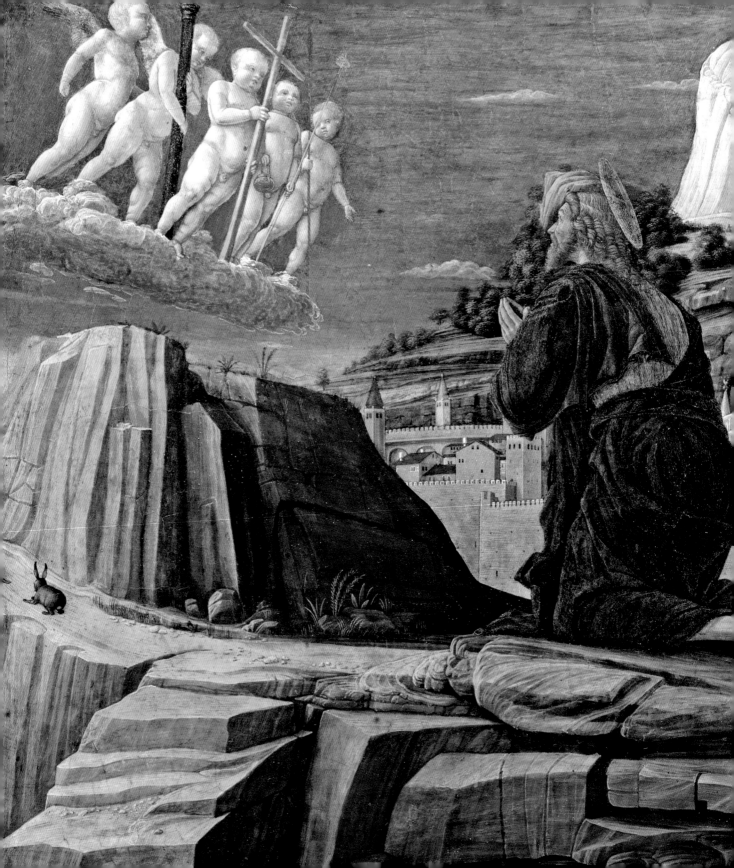

The Early Blossoming

During the fourteenth and fifteenth centuries, a remarkable period of cultural and intellectual blossoming in Italy, artists tentatively began to explore the use of perspective and pioneered a more intense naturalism.

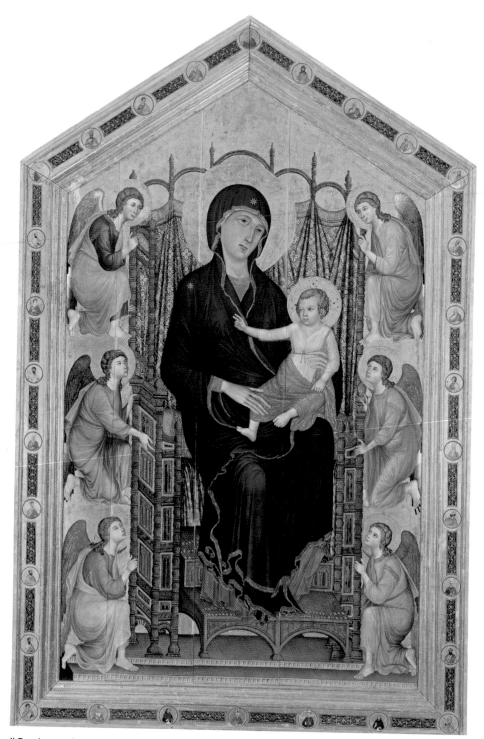

Duccio di Buoninsegna (*c.* 1255–*c.* 1318)
Tempera on panel, 450 x 290 cm (177 x 114 in)
• Galleria degli Uffizi, Florence

The Rucellai Madonna, 1285 Previously attributed to Cimabue, this early work by Duccio combines formal Byzantine elements with delicate Gothic features, evident in the softness and sweetness of the angels, the distribution of light and shade and the elegant lines.

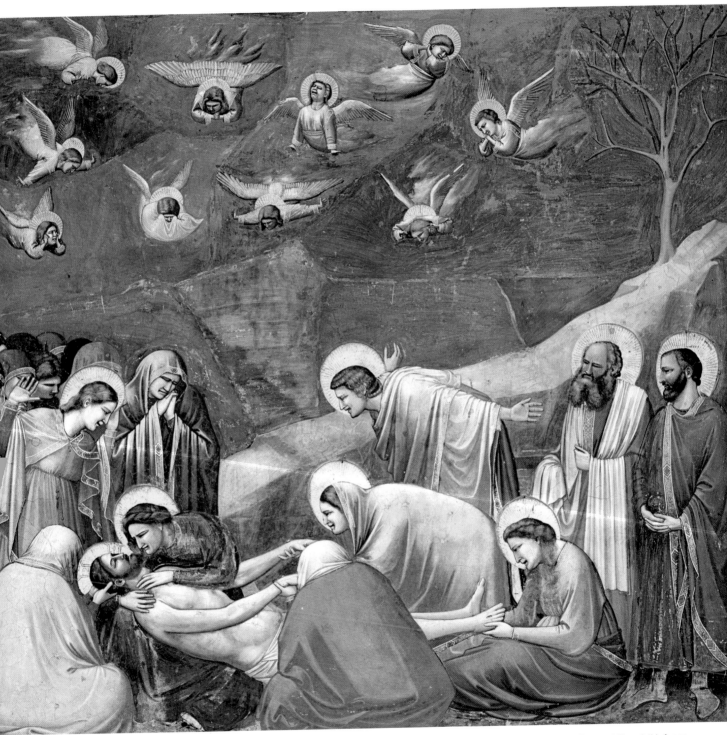

Giotto di Bondone (1266–1337)
Fresco, 200 x 185 cm (78¾ x 72⅘ in)
• Scrovegni (Arena) Chapel, Padua

The Lamentation of Christ, *c.* 1305 One of the most powerful images in the Scrovegni Chapel, this fresco is important for its economical compositional structure and emotionally expressive style. Foreshortened angels dart about in hysterical grief while, below, mourners exhibit varying gestures of despair.

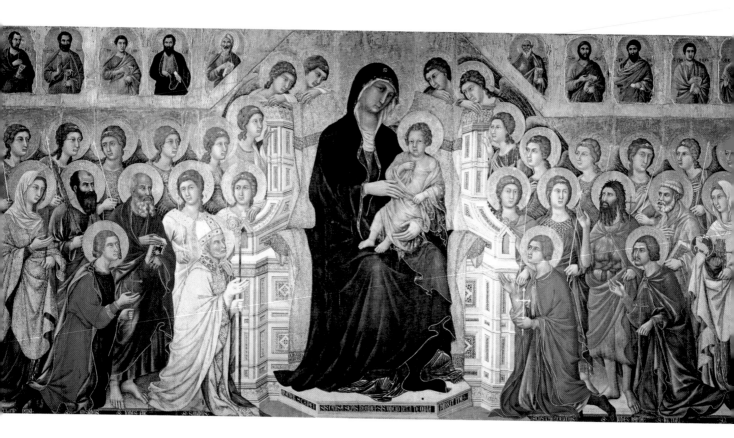

Duccio di Buoninsegna (c. 1255–c. 1318)
Tempera and gold on panel, 213 x 396 cm (84 x 156 in)
• Museo dell'Opera Metropolitana del Duomo, Siena

Maestà, 1308–11 Created for Siena Cathedral, this double-sided altarpiece shows the Madonna and Child enthroned with saints and angels (front), and scenes from the life of Christ (reverse), revealing Duccio's lyricism and his role in developing the art of narrative.

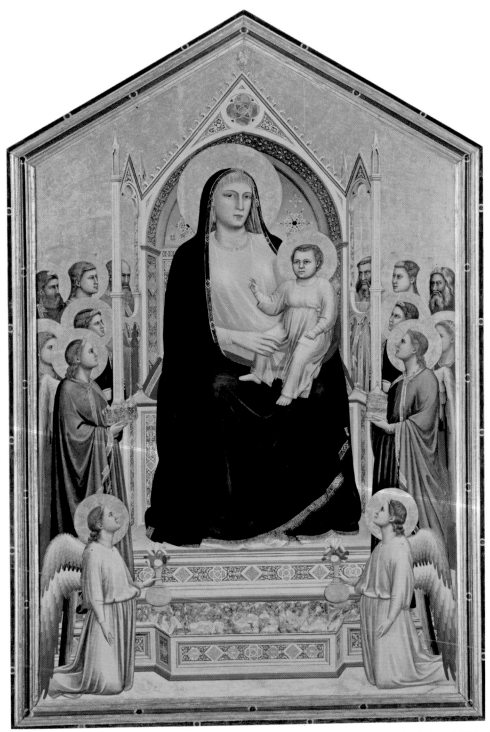

Giotto di Bondone (1266–1337)
Tempera on panel, 325 x 204 cm (128 x 80 in)
• Galleria degli Uffizi, Florence

The Ognissanti Madonna, *c.* 1310 Painted for the Florentine Ognissanti (All Saints) Church, this panel marks the start of a new naturalistic art. Giotto's figures have substance, dimensionality and bulk – the contours of the Madonna's body are visible through her robe.

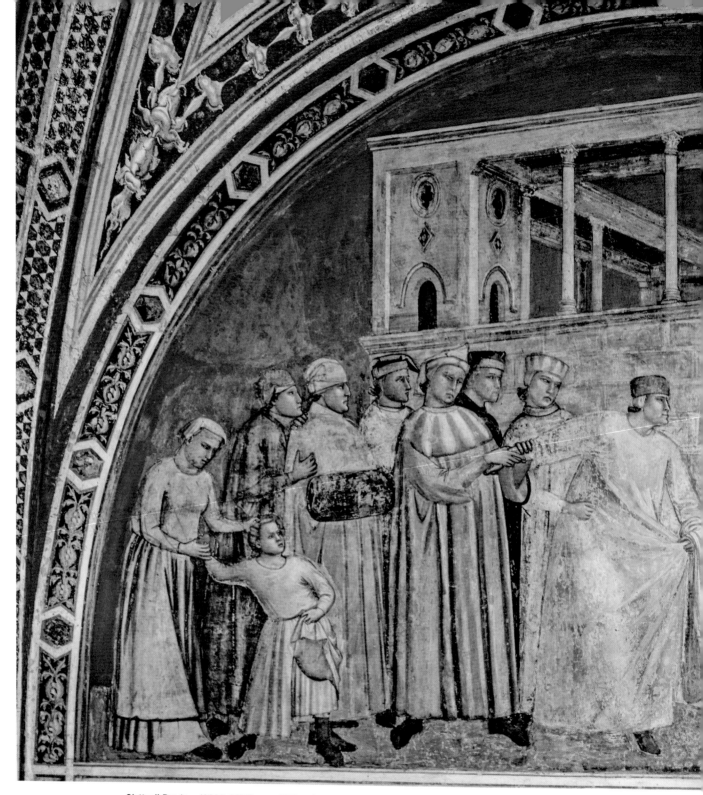

Giotto di Bondone (1266–1337)
Fresco, 280 x 450 cm (110¼ x 177¼ in)
• Bardi Chapel, Basilica di Santa Croce, Florence

St Francis's Renunciation of Worldly Goods, *c.* **1325–28** Giotto conveys the emotional content of Francis's renunciation of a worldly life for a religious one. In front of a building (viewed from an oblique angle), Francis's father angrily lunges towards his son, who stands wrapped in a cloak.

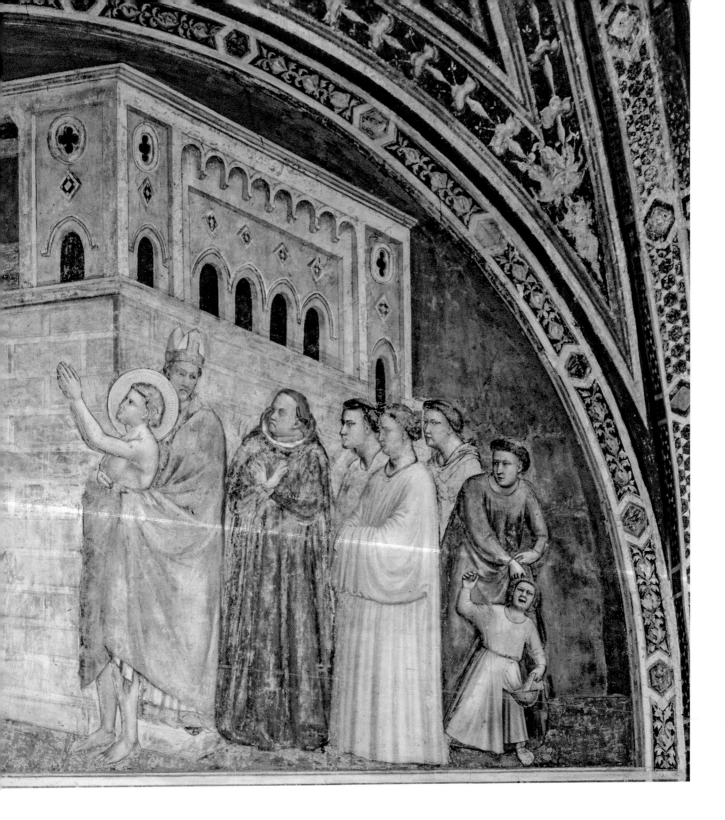

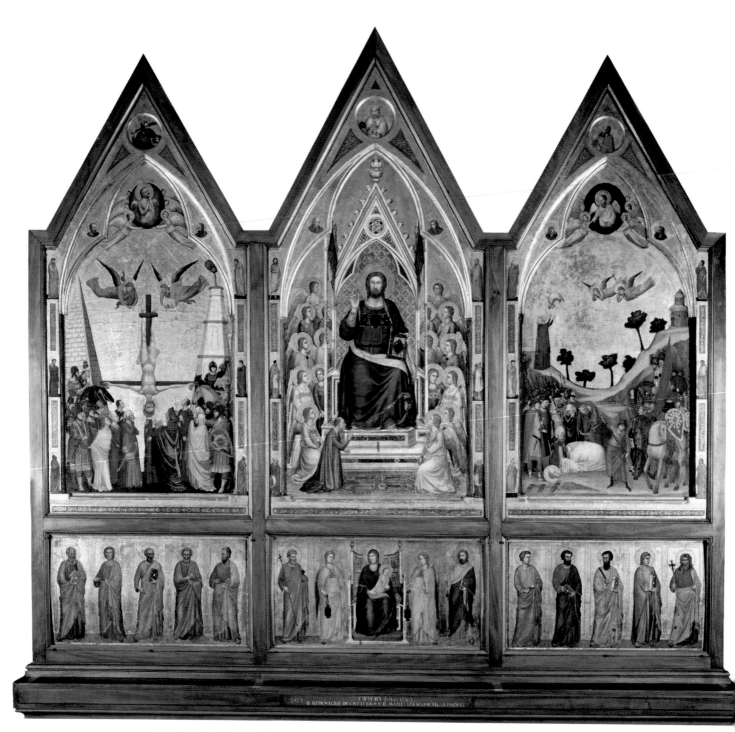

Giotto di Bondone (1266–1337)

Tempera on panel, 178 x 89 cm (70 x 35 in) (central panel);
c. 168 x 83 cm (66 x 32¾ in) (side panels); c. 45 x c. 83 cm
(17¾ x 32¾ in) (each predella section) • Pinacoteca Vaticana, Rome

The Stefaneschi Triptych, *c.* **1320** Commissioned by Cardinal Jacopo Stefaneschi for the old St Peter's Basilica, this triptych depicts Christ enthroned and the martyrdom of saints Peter and Paul on one side (shown above), and Saint Peter enthroned alongside saints (with Cardinal Stefaneschi himself kneeling at Peter's right) on the other.

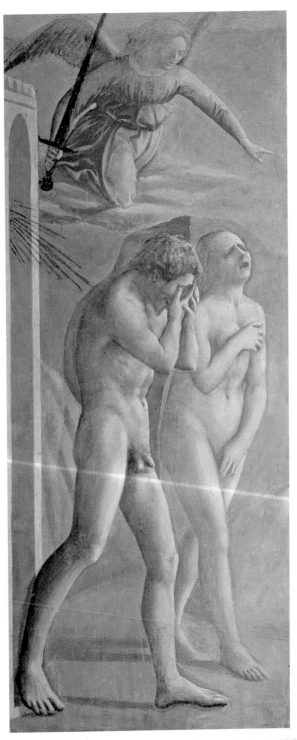

Masaccio (1401–28)
Fresco, 208 x 88 cm (82 x 35 in)
• Brancacci Chapel, Santa Maria del Carmine, Florence

The Expulsion from the Garden of Eden, *c.* **1425–27** This boldly executed fresco combines physical realism with psychological depth, as Eve cries out in anguish and Adam covers his face. Masaccio depicts slanted light from an outside source to create deep relief.

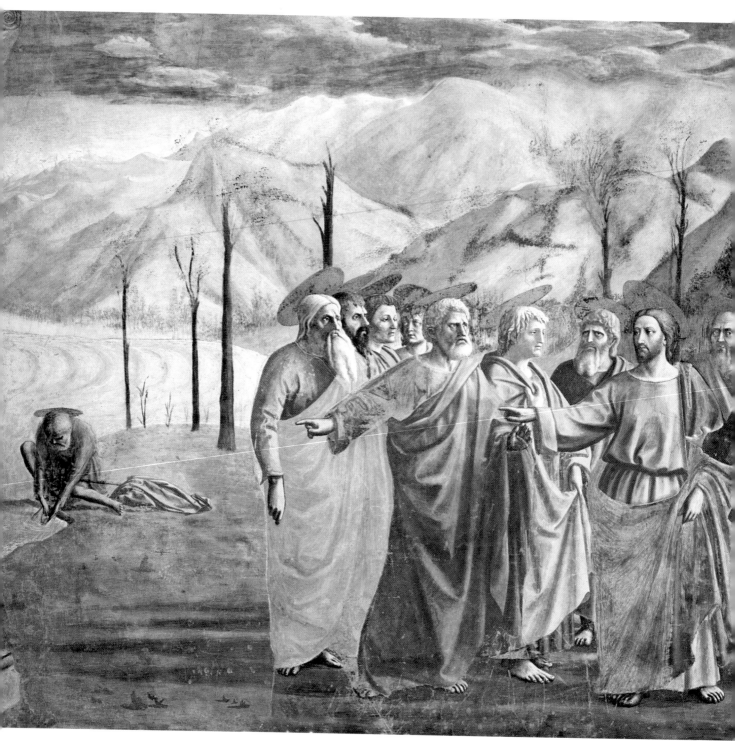

Masaccio (1401–28)
Fresco, 247 x 597 cm (97¼ x 235 in)
• Brancacci Chapel, Santa Maria del Carmine, Florence

The Tribute Money, *c.* **1425–27** Three moments are depicted in the same scene – a tax collector demanding money, Jesus instructing Peter to find the money in a fish's mouth and Peter paying the tax collector. Linear perspective is used and the figures cast shadows.

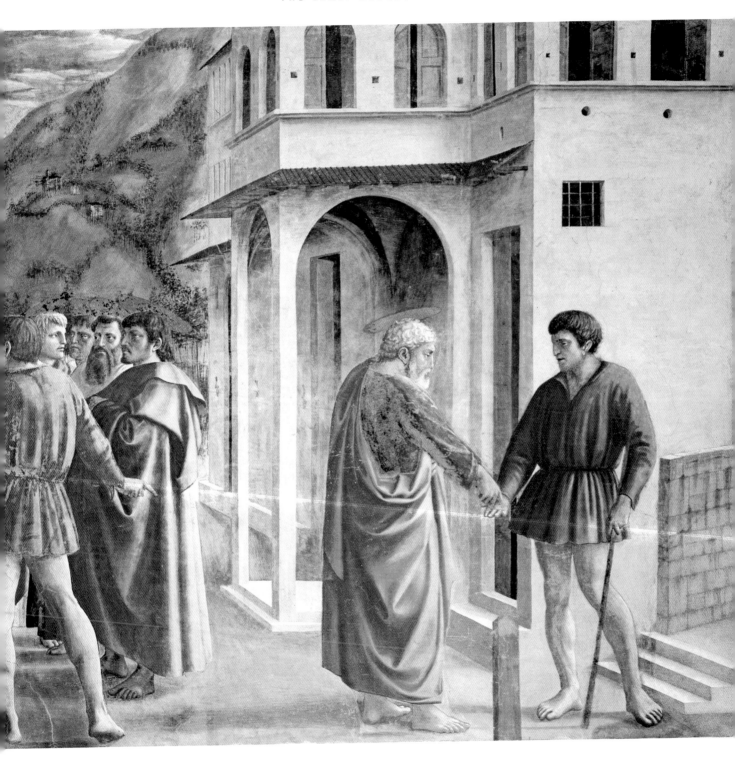

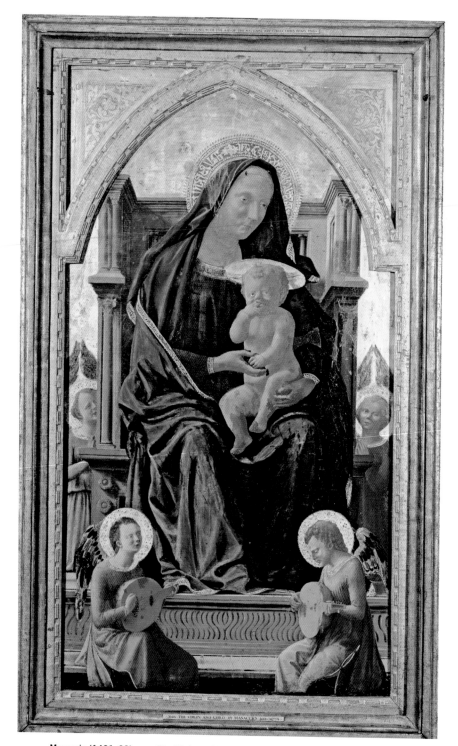

Masaccio (1401–28)
Tempera on panel, 134.8 x 73.5 cm (53 x 29 in)
• The National Gallery, London

The Virgin and Child, 1426 Masaccio makes innovative use of single-point perspective. This can be seen in the treatment of the throne and the musical instruments. The plump Christ Child is human and convincing.

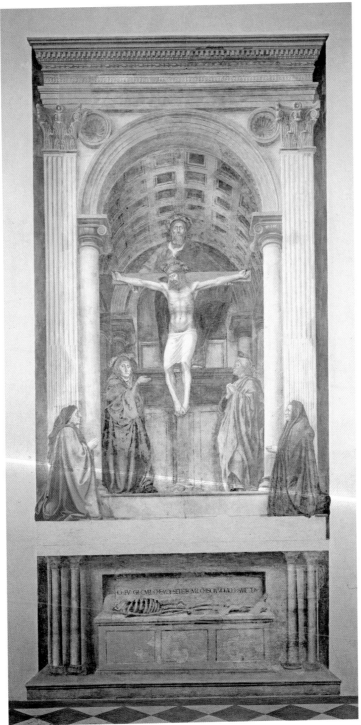

Masaccio (1401–28)

Fresco, 667 x 317 cm (263 x 125 in)
• Santa Maria Novella, Florence

Holy Trinity, c. 1427 One of best examples of the application of mathematics to the depiction of space, the illusionism of this work is breathtaking. The figures, arranged in an ascending pyramid shape, are set in a barrel-vaulted hall shown using linear perspective.

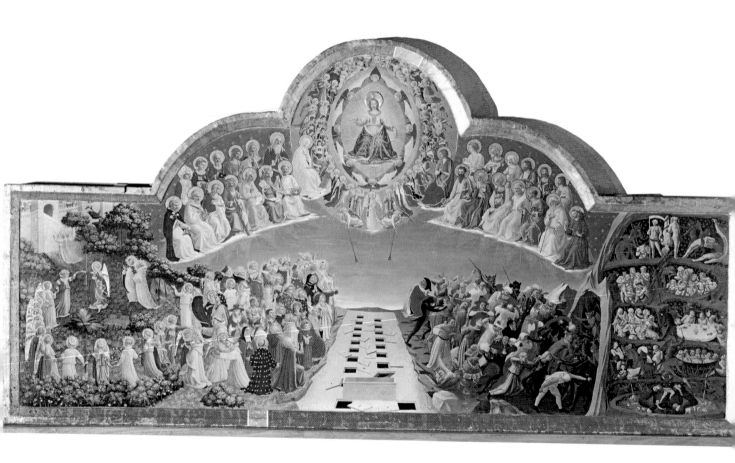

Fra Angelico (c. 1395–1455)
Tempera on panel, 105 x 210 cm (41⅓ x 82¾ in)
• Museo di San Marco, Florence

Last Judgement, c. 1431 Adapting fourteenth-century prototypes and Dante's (1265–1321) vision of Hell in the *Divine Comedy* (1320), Fra Angelico's depiction of Christ, angels, saints and the blessed and damned includes the perspectival device of a receding rectangle of empty tombs.

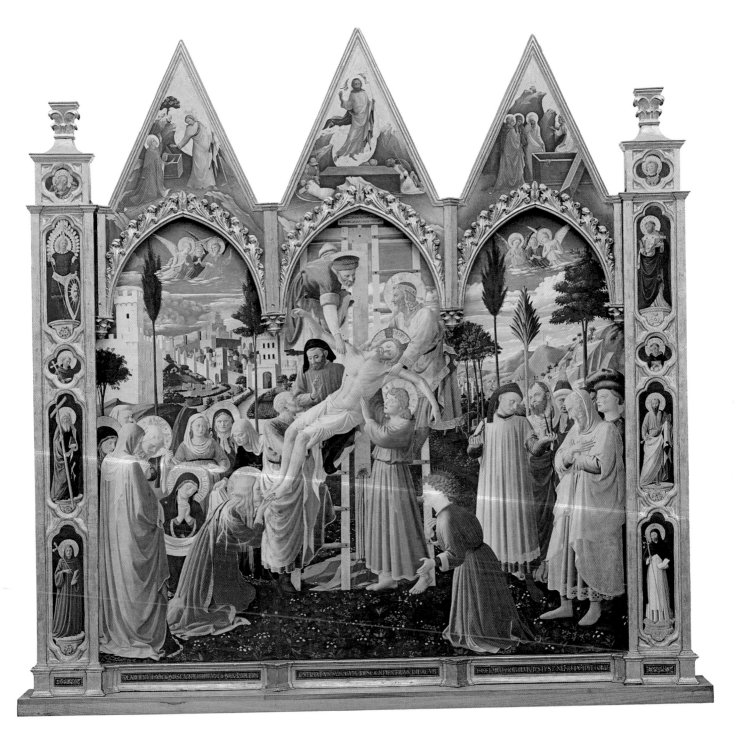

Fra Angelico (c. 1395–1455)
Tempera on panel, 176 x 185 cm (69 x 73 in)
• Museo di San Marco, Florence

Deposition of Christ, c. 1434 Started by Lorenzo Monaco (1370–1425), Fra Angelico went on to complete this poignant altarpiece. Set in a vast Tuscan landscape, sharply outlined figures are arranged in interconnected groups, indicating the artist's knowledge of Early Renaissance formalism.

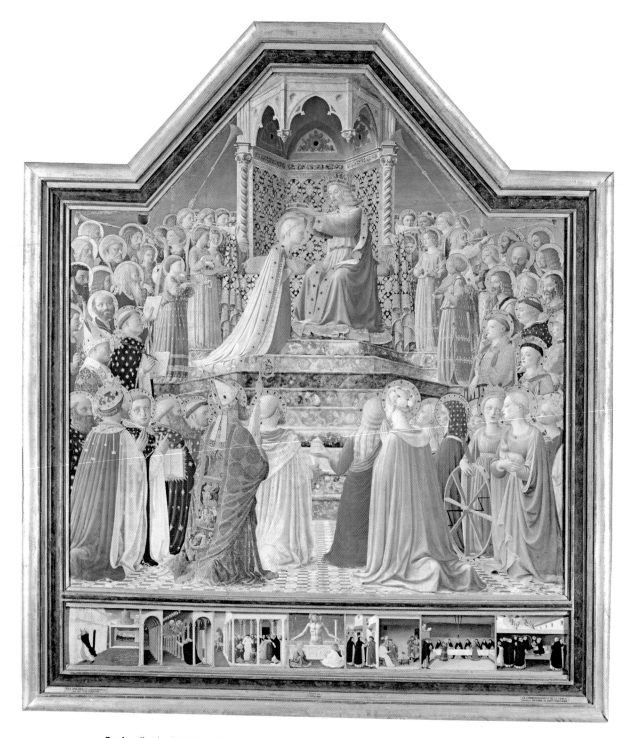

Fra Angelico (*c.* 1395–1455)
Tempera on panel, 213 x 211 cm (84 x 83 in)
• Musée du Louvre, Paris

Coronation of the Virgin, *c.* 1434–35 The court of Heaven is gathered (and carefully organized) to celebrate the Virgin. Fra Angelico's use of linear perspective and the sculptural volume of his figures indicate the influence of Masaccio.

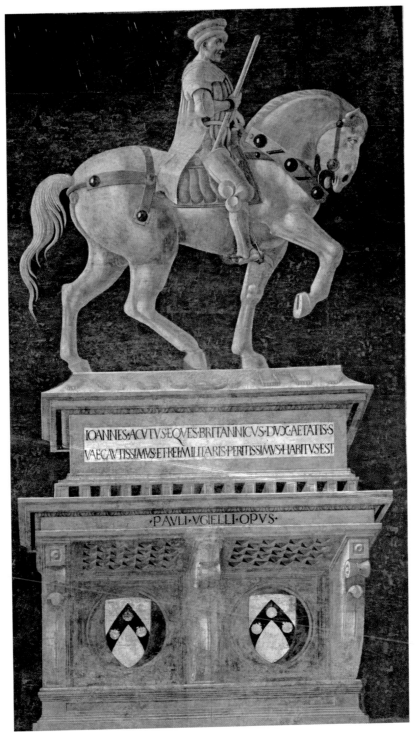

**Paolo Uccello (1397–1475), frame added by
Lorenzo di Credi (*c.* 1459–1537)**

Fresco, 820 x 515 cm (323 x 203 in)

• Basilica di Santa Maria del Fiore, Florence

Funerary Monument to Sir John Hawkwood, 1436 Commemorating an English mercenary captain who
led the Florentines to victory in battle, Uccello uses perspective (full frontal and foreshortening) and
three-dimensional figure representation, reinforced by the monochrome *terra verde* effect, to create the
illusion of a statue.

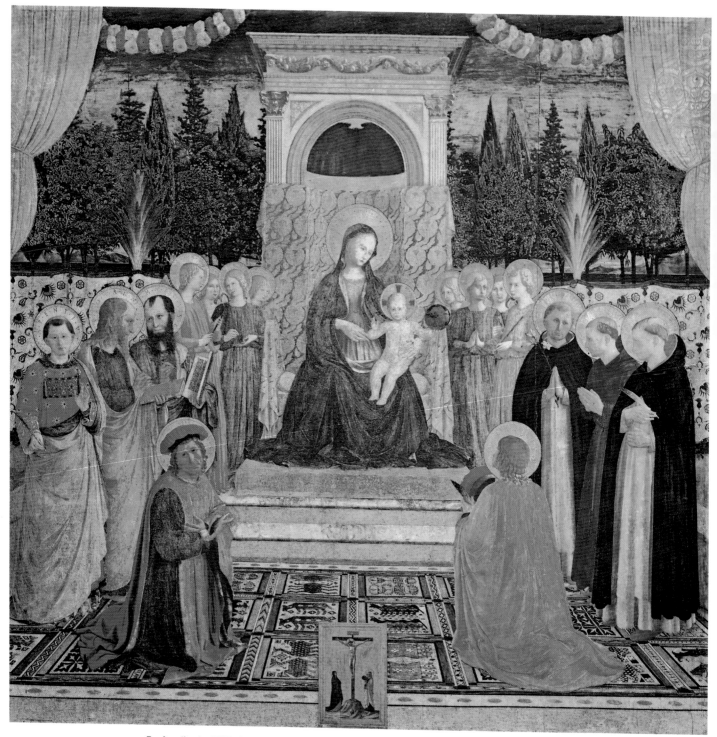

Fra Angelico (*c.* 1395–1455)
Tempera on panel, 220 x 227 cm (87 x 89 in)
• Museo di San Marco, Florence

San Marco Altarpiece, *c.* 1438–40 Commissioned by Cosimo de' Medici (the Medicis' patron saints, Cosmas and Damian, kneel before the throne), Fra Angelico demonstrates his revolutionary compositional approach, with the lines of the intricately patterned carpet and the overlapping saints giving a sense of depth.

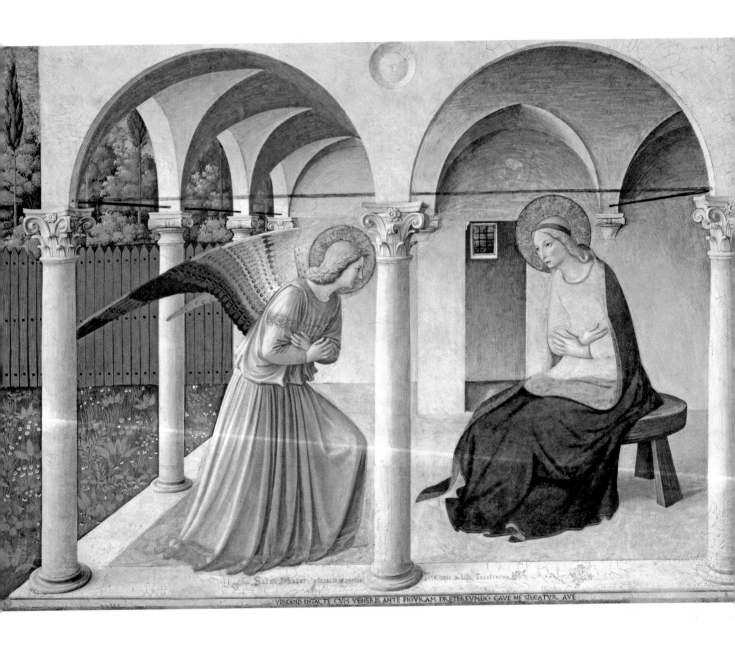

Fra Angelico (c. 1395–1455)
Fresco, 187 x 157 cm (74 x 62 in)
• Museo di San Marco, Florence

The Annunciation, c. 1438–45 In this simple, serene scene of Mary and Gabriel (intended to inspire devotion), the figures are painted shallowly, recalling pre-Renaissance artists, in an austere setting, but the flourishing plants show a surprising level of realism.

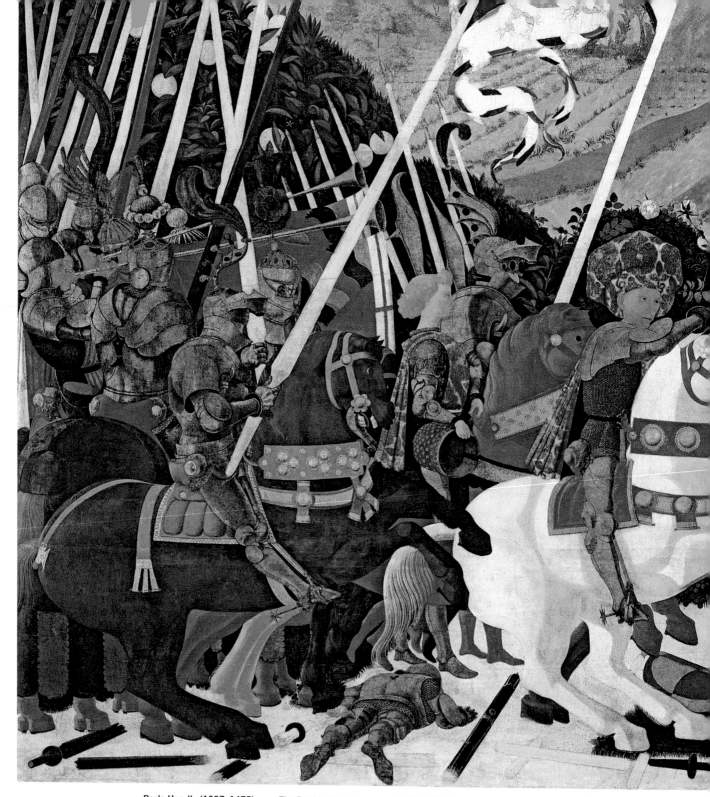

Paolo Uccello (1397–1475)

Tempera on panel, 182 x 320 cm (72 x 126 in)

• The National Gallery, London

The Battle of San Romano, *c.* **1438–40** This panel depicts a Florentine victory over Siena led by Niccolò da Mauruzi da Tolentino (*c.* 1350–1435). Sitting on his white horse, he dominates the centre of the scene. The pattern of broken lances and foreshortened shapes reveal Uccello's severe formal rigour.

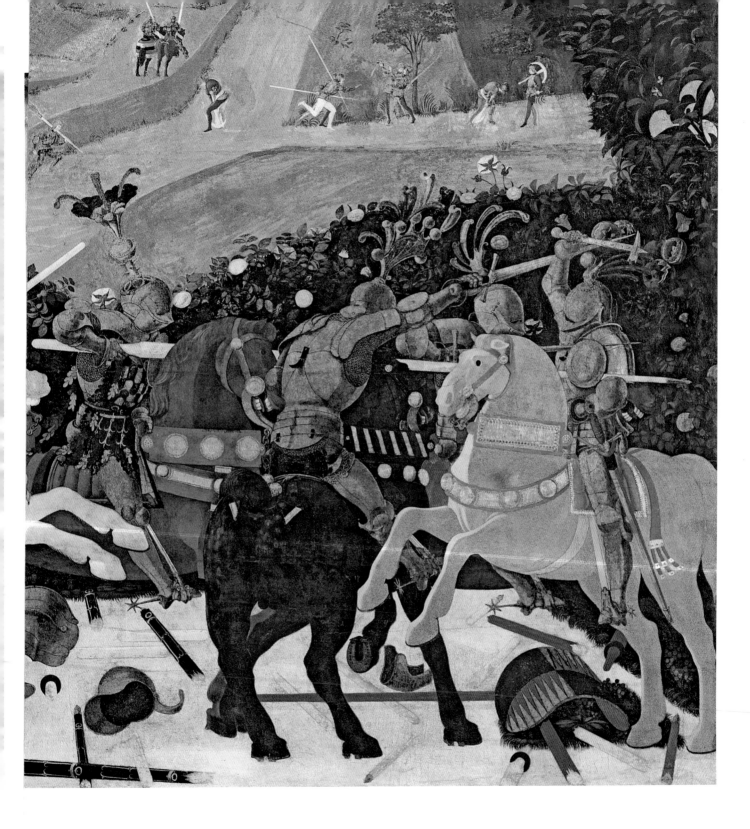

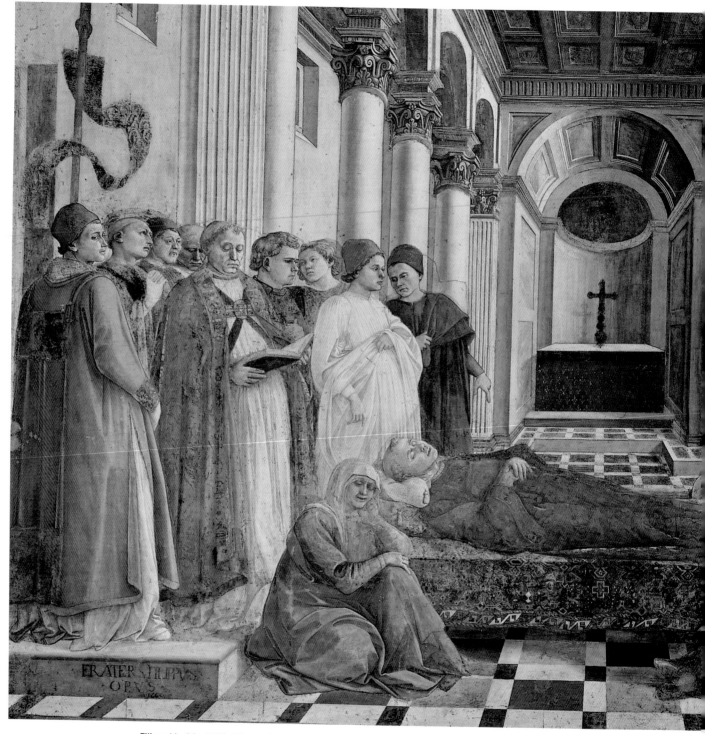

Filippo Lippi (*c.* 1406–69)
Fresco • Cappella Maggiore, Duomo, Prato

The Funeral of St Stephen, 1452–65 In this complex scene with its plunging recession, the deceased saint is laid out on the nave's central axis. He is surrounded by mourners whose figural types show Lippi's debt to Masaccio. The crowd of prelates includes the artist himself.

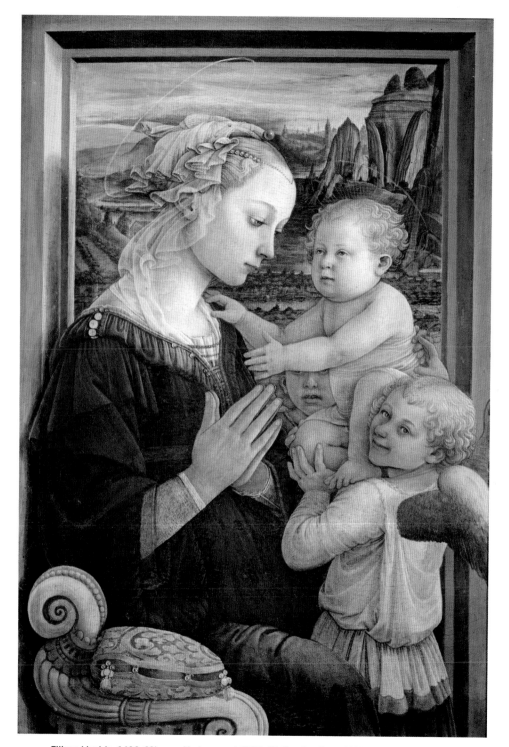

Filippo Lippi (*c.* 1406–69)
Tempera on panel, 92 x 63.5 cm (36 x 25 in)
• Galleria degli Uffizi, Florence

Madonna and Child with Two Angels, *c.* 1460–65 While chaplain to a convent, Lippi saw the beautiful novice Lucrezia Buti, whom he persuaded to run away with him. The Mary in this painting has traditionally been identified as Lucrezia. Her sculpted face, drapery and solid form are striking.

Filippo Lippi (c. 1406–69)
Oil on panel, 129.5 x 118.5 cm (51 x 46⅔ in)
• Gemäldegalerie, Staatliche Museen zu Berlin

Adoration in the Forest, 1458–60 Painted for the chapel of Cosimo de' Medici's palace, this nativity scene is unusual. The setting is a dark, wooded wilderness. Joseph and the typical animals are missing, but the Holy Trinity is depicted.

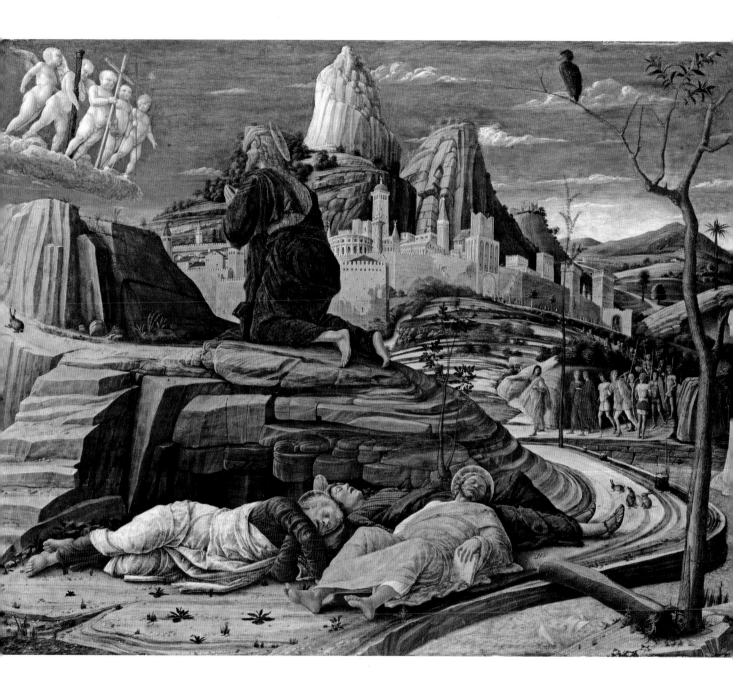

Andrea Mantegna (*c.* 1431–1506)
Tempera on panel, 62.9 x 80 cm (25 x 31½ in)
• The National Gallery, London

The Agony in the Garden, *c.* 1455–56 Angels zoom towards Jesus on a cloud, the disciples sleep and Judas approaches with soldiers to arrest Jesus. The stage setting is made up of fissured rock formations. Jerusalem, transformed into a pink city, features Roman and Renaissance structures.

Piero della Francesca (*c.* 1415–92)
Fresco, 225 x 200 cm (89 x 79 in)
• Museo Civico, Sansepolcro

The Resurrection, *c.* 1463–65 Piero shows Jesus stepping out of a Roman sarcophagus and, in the foreground, sleeping soldiers – one, holding a lance, does not seem to have legs! The organization of the figures reveals Piero's concern with geometric order and harmony.

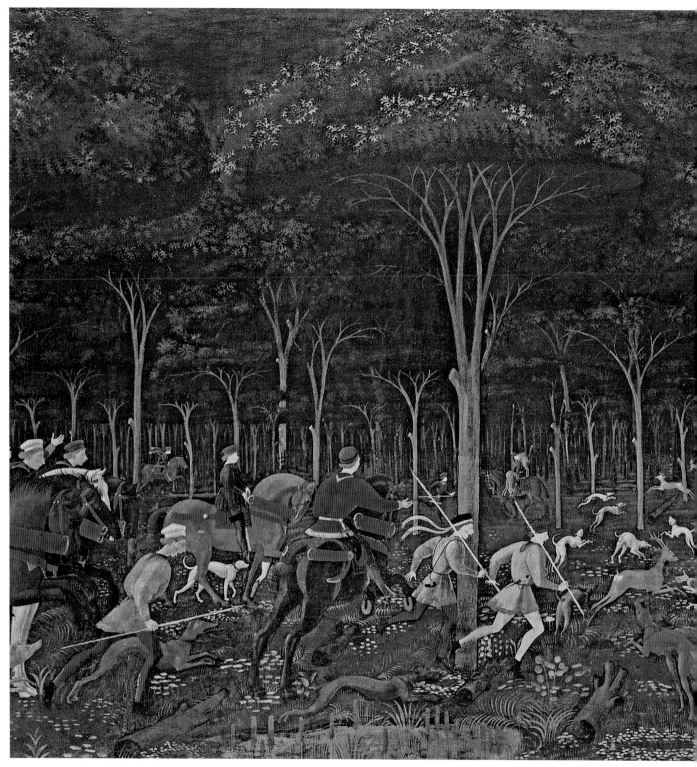

Paolo Uccello (1397–1475)

Tempera and oil, with traces of gold, on panel, 73.3 x 177 cm (29 x 70 in)
• Ashmolean Museum, Oxford

The Hunt in the Forest, *c.* 1465–70 Possibly intended as an elaborate decoration for a linen box, this nocturnal landscape demonstrates the optical and poetic effects of perspective. The huntsmen, the trees and the dogs chasing deer lead towards a vanishing point deep in the forest.

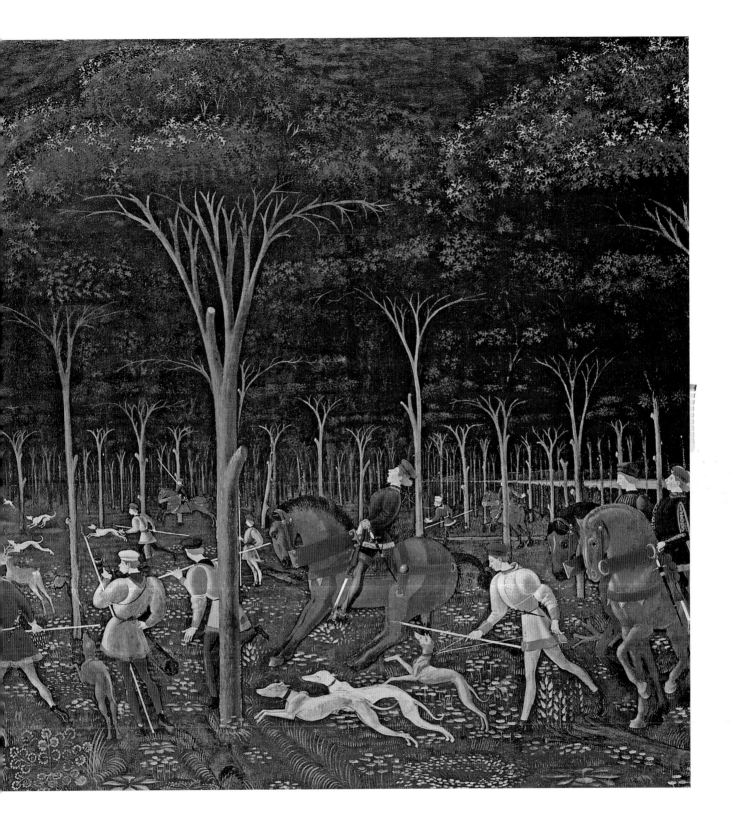

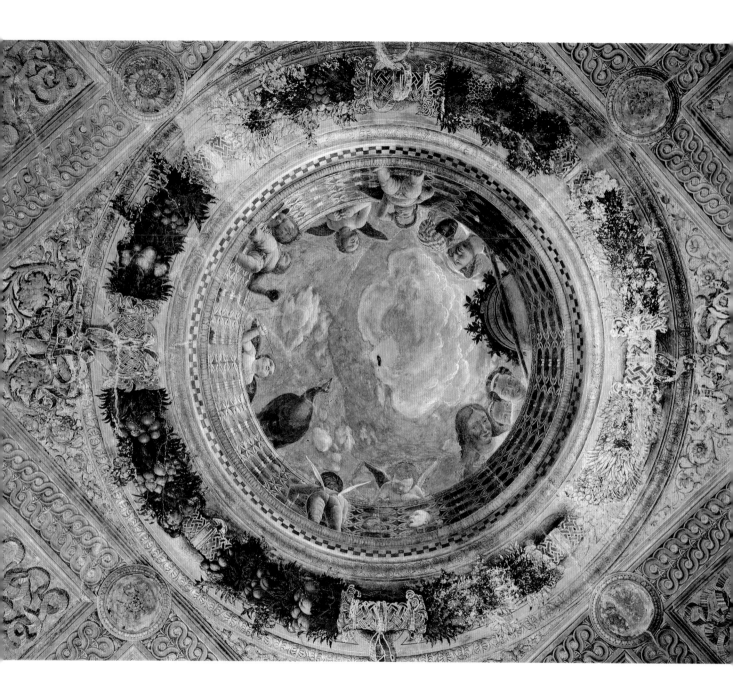

Andrea Mantegna (*c.* 1431–1506)
Fresco, diameter 270 cm (106⅓ in)
• Camera degli Sposi, Palazzo Ducale, Mantua

Ceiling Oculus, 1465–74 For Mantua's ducal palace, Mantegna painted a false ceiling above the Camera degli Sposi ('bridal chamber'). Around a trompe l'oeil oculus (a circular opening to the sky), assorted figures and cherubs lean over the parapet in dramatically foreshortened perspective.

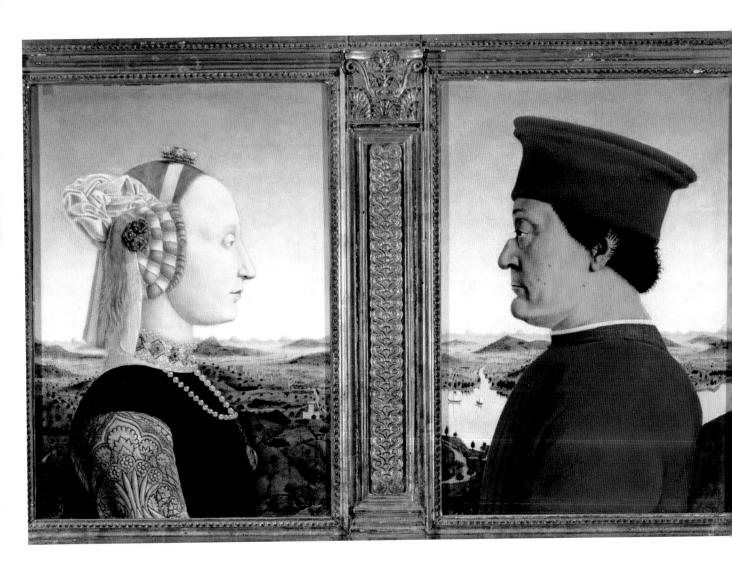

Piero della Francesca (*c.* 1415–92)

Tempera on panel, each panel 47 x 33 cm (19 x 13 in)

• Galleria degli Uffizi, Florence

Portraits of the Duke and Duchess of Urbino, *c.* **1467–72** This double portrait of Federico da Montefeltro (1420–82) and his wife Battista Sforza (1446–72) was probably commissioned after Battista's death as a memorial. Viewers see Federico's left side because he had lost his right eye in a jousting accident.

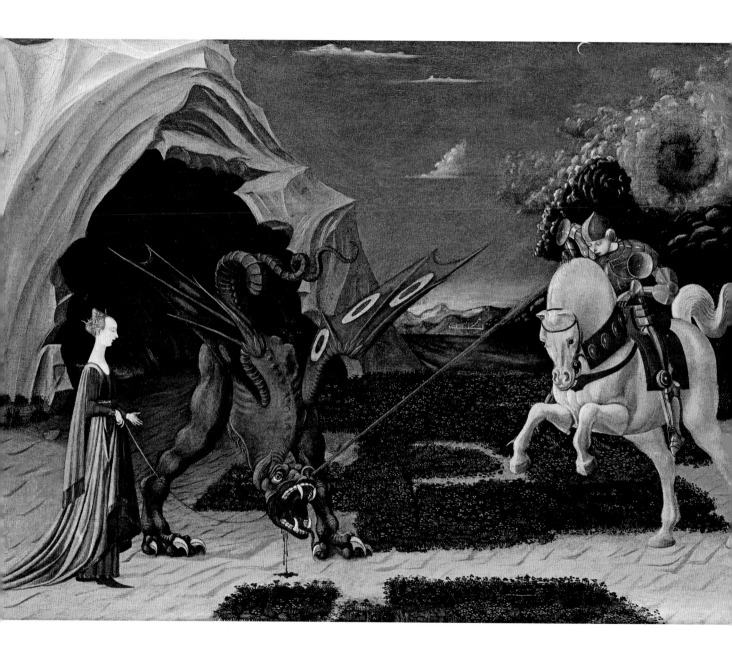

Paolo Uccello (1397–1475)
Oil on canvas, 55.6 x 74.2 cm (22 x 29 in)
• The National Gallery, London

Saint George and the Dragon, *c.* **1470** Featuring two episodes from the story of Saint George (his defeat of the dragon and the rescued princess bringing the dragon to heel), Uccello uses a subtle palette and foreshortening effects to suggest a complex three-dimensional space.

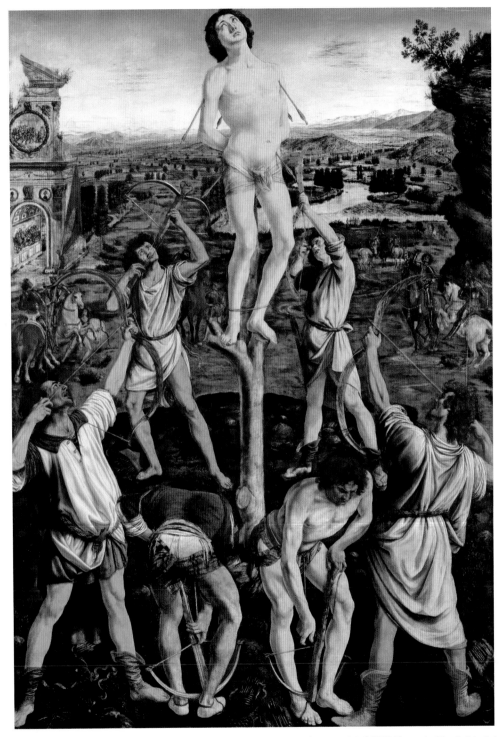

**Antonio del Pollaiuolo (*c.* 1432–98) and
Piero del Pollaiuolo (1443–96)**

Oil on wood, 291.5 x 202.6 cm (115 x 80 in)
• The National Gallery, London

The Martyrdom of Saint Sebastian, completed 1475 The work of the Pollaiuolo brothers, this painting is notable for the symmetrically arranged archers in the foreground. They have three basic poses, seen from different angles, giving a solidity to their bodies.

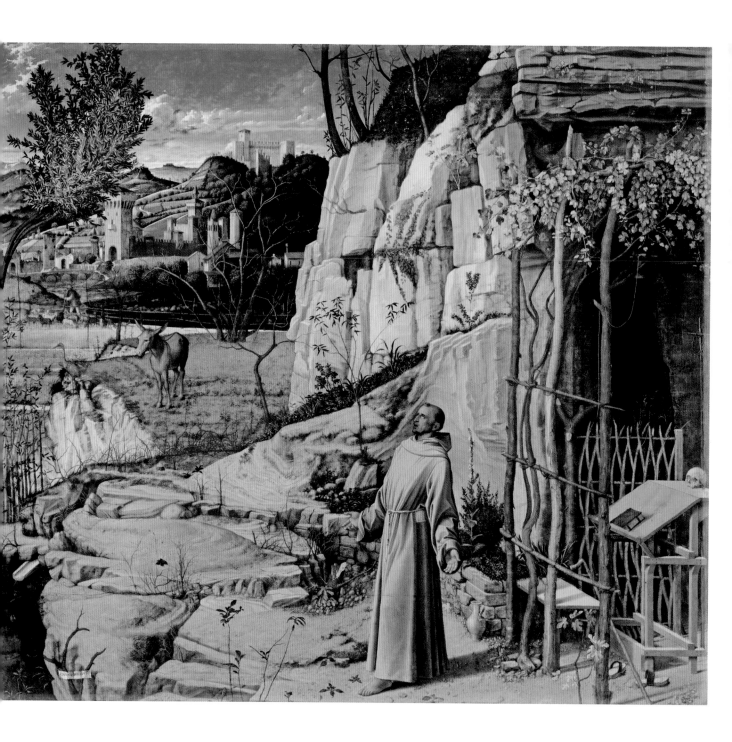

Giovanni Bellini (c. 1430–1516)
Oil on panel, 124.1 x 140.5 cm (49 x 55⅓ in)
• Frick Collection, New York

St Francis in the Desert, c. 1476–78 Using the new medium of oil, Bellini mixes Flemish symbolic elements with Franciscan ideals. The magnetic saint is depicted with his arms spread wide, gazing upwards. The rocky foreground is surrounded by a verdant world of fields and orchards.

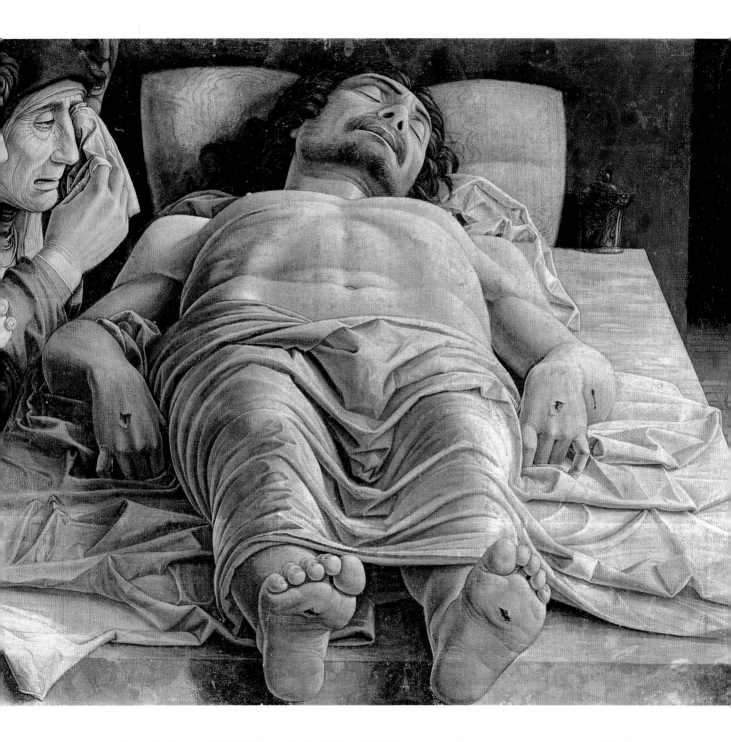

Andrea Mantegna (c. 1431–1506)
Tempera on canvas, 68 x 81 cm (27 x 32 in)
• Pinacoteca di Brera, Milan

The Dead Christ, c. 1480 This daringly experimental work is a study in exaggerated foreshortening. Mantegna presents a harrowing depiction of Christ's corpse and the mourners squeezed up against it, using a sharp line and a limited range of colours.

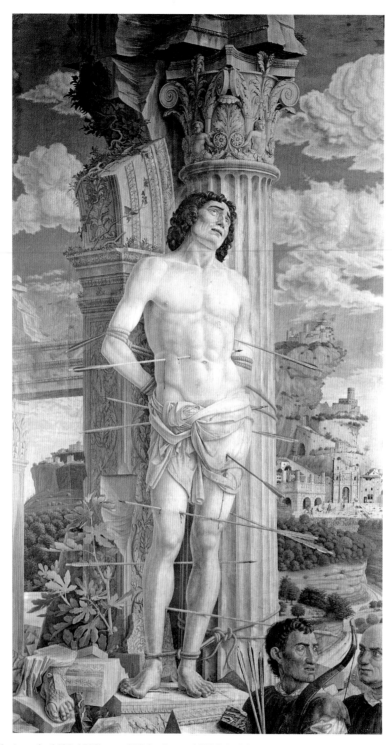

Andrea Mantegna (*c.* 1431–1506)
Tempera on canvas, 255 x 140 cm (100⅜ x 55 in)
• Musée du Louvre, Paris

St Sebastian, *c.* 1480 Saint Sebastian, whose idealized form here evokes sculpture, was considered a protector against the plague during the Renaissance. Observed from a low perspective, he is tied against a meticulously depicted temple fragment, linking the antique and Christian worlds.

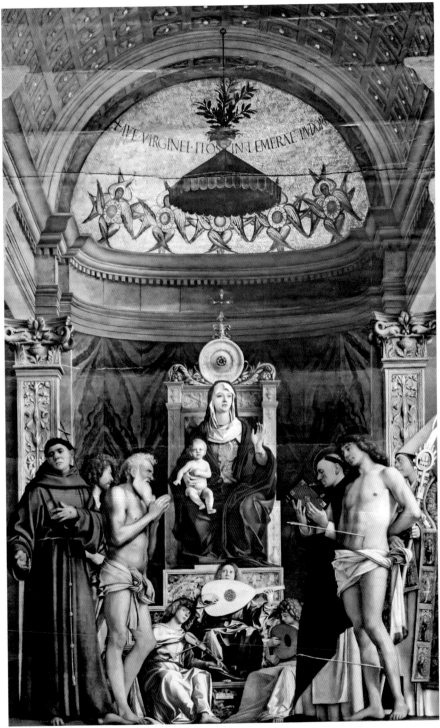

Giovanni Bellini (c. 1430–1516)
Oil on panel, 471 x 258 cm (185⅔ x 102 in)
• Gallerie dell'Accademia, Venice

San Giobbe Altarpiece, c. 1487 This celebrated painting played a key role in the development of the *sacra conversazione* ('holy conversation') altarpiece type. Mary, the baby Jesus and saints are housed in a distinctive spatial construction illusionistically and physically contiguous with the viewer's space.

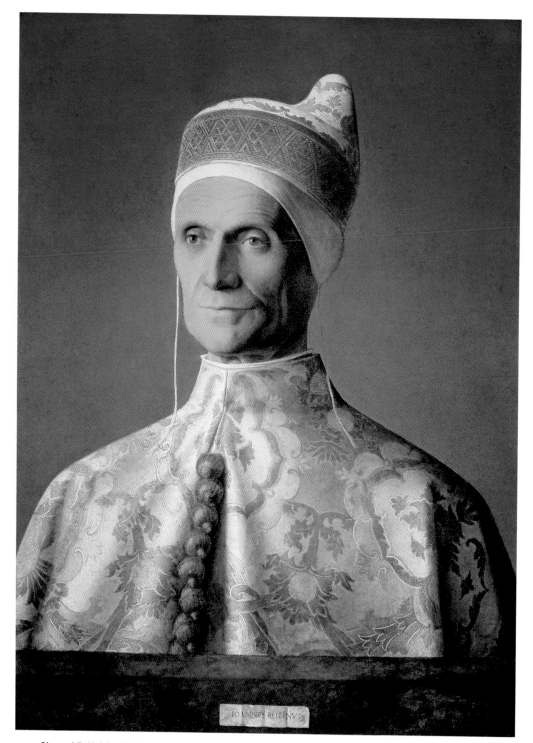

Giovanni Bellini (*c.* 1430–1516)
Oil on panel, 61.6 x 45.1 cm (24¼ x 17⅘ in)
• The National Gallery, London

Doge Leonardo Loredan, *c.* 1501–02 In this startling portrait, Leonardo Loredan (1436–1521), the Venetian Republic's head of state, is adorned in his official dress – a white and gold damask mantle with bell buttons and a pointed hat (*corno*). Loredan's ascetic face looks tangibly real.

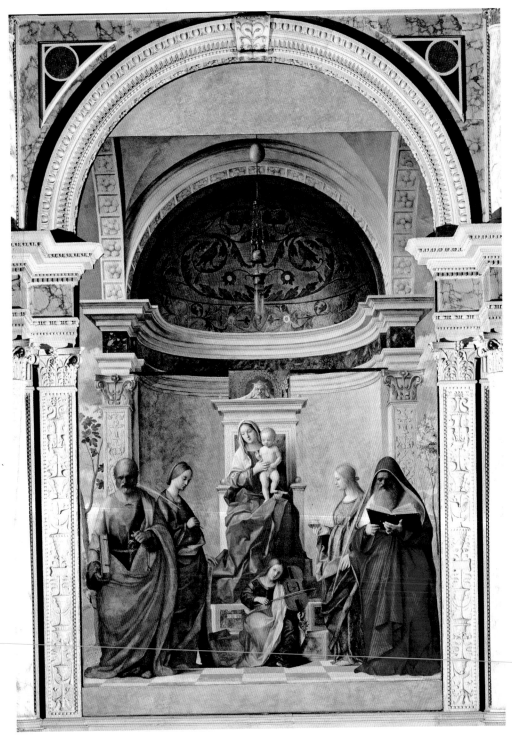

Giovanni Bellini (c. 1430–1516)
Oil on panel, transferred to canvas, 500 x 235 cm (200 x 93 in)
• San Zaccaria, Venice

San Zaccaria Altarpiece, 1505 The Madonna and Child, saints Peter, Catherine, Lucy and Jerome and a musical angel have an appearance of solidity and stillness. The fictive architecture and saturated colours add to the realism of the scene.

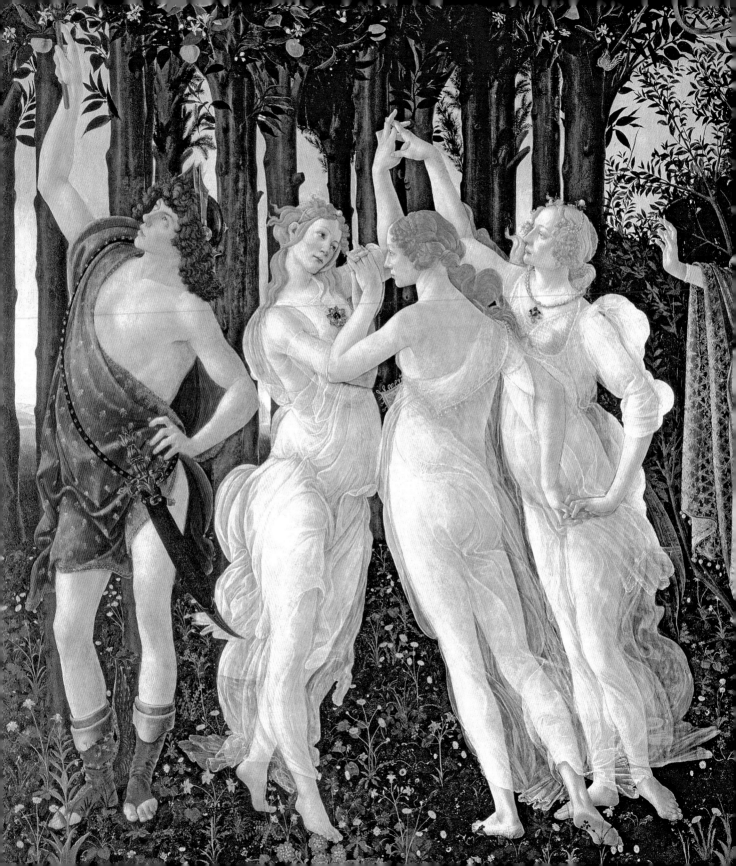

A Flowering Imagination

The end of the fifteenth century and first part of the sixteenth century saw a flowering of Italian visual culture. Artists looked to the ancient world for inspiration but were also fiercely forward thinking, none more so than Leonardo, Michelangelo and Raphael.

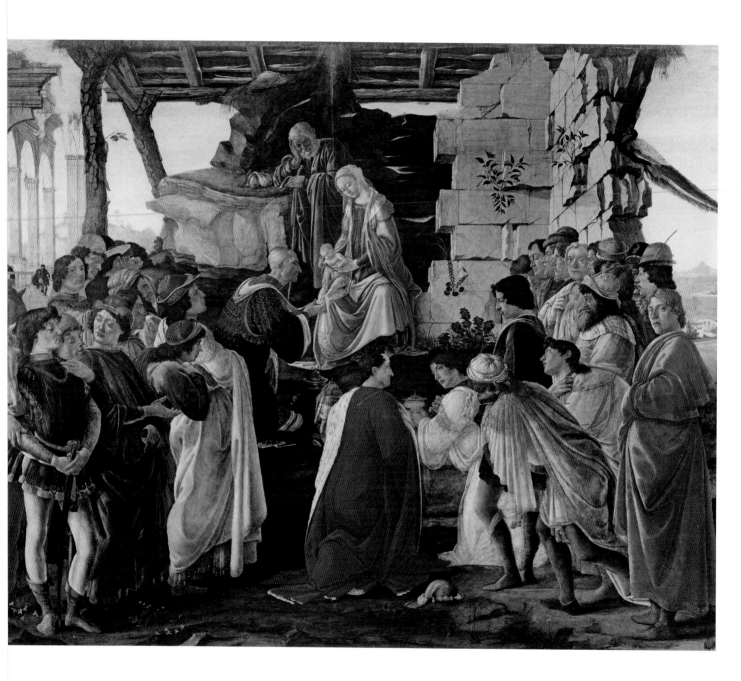

Sandro Botticelli (1445–1510)
Tempera on panel, 111 x 134 cm (44 x 53 in)
• Galleria degli Uffizi, Florence

Adoration of the Magi, _c._ 1475 Commissioned by a wealthy Florentine in honour of the Medici family (many of whom are depicted in the painting), this work highlights Botticelli's attention to detail (seen in the ancient ruins, garments and variety of gestures).

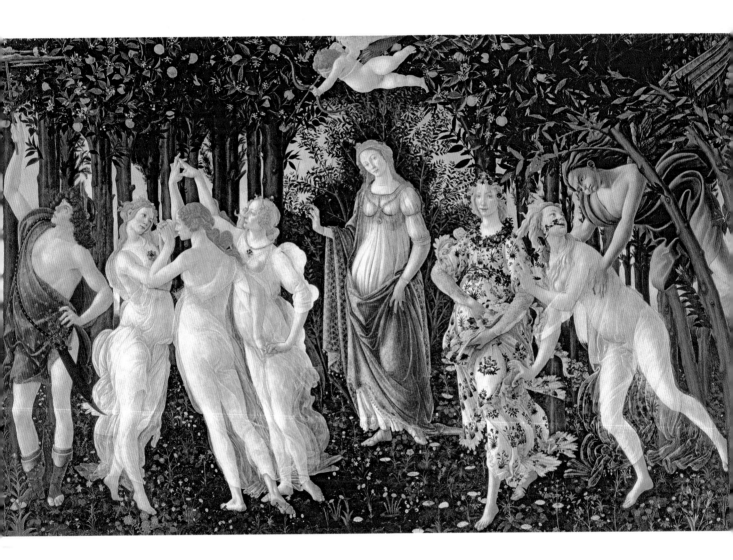

Sandro Botticelli (1445–1510)
Tempera on panel, 202 x 314 cm (80 x 124 in)
• Galleria degli Uffizi, Florence

Primavera, *c.* 1478 Primavera (or 'The Allegory of Spring') features Venus (centre), with Cupid above. The Three Graces (left) dance next to Mercury. Zephyrus (right), the west wind, pursues the nymph Chloris, whom he transforms into Flora, the Spring goddess.

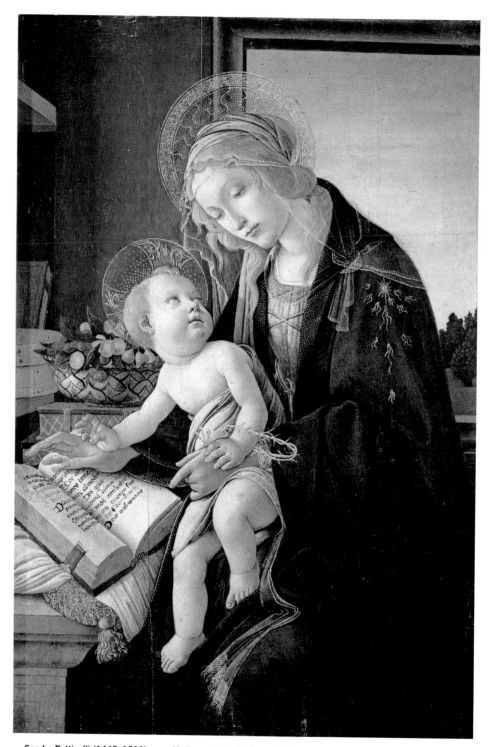

Sandro Botticelli (1445–1510)
Tempera on panel, 58 x 39.6 cm (23 x 15⅗ in)
• Museo Poldi Pezzoli, Milan

Madonna of the Book, *c*. 1480 Showing Mary and the baby Jesus reading a Book of Hours, this painting reflects Botticelli's mature, linear style. The artist used gold filigree to decorate robes and objects, and symbolic elements are included.

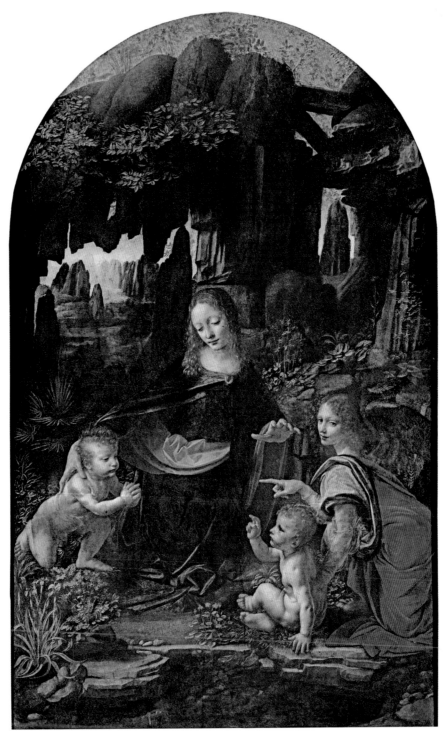

Leonardo da Vinci (1452–1519)
Oil on panel, 199 x 122 cm (78⅓ x 48 in)
• Musée du Louvre, Paris

The Virgin of the Rocks, *c.* **1483–86** This, the first of two versions of the same subject, shows graceful figures grouped in a pyramid shape, located in a rocky landscape, unifying the composition. Using light and shadow to model forms, Leonardo also precisely depicts plants and flowers.

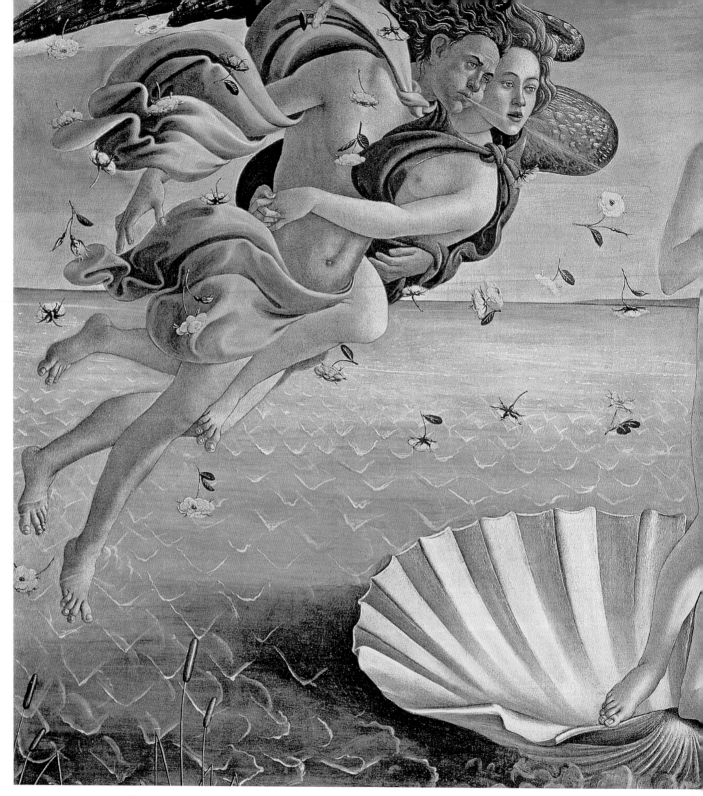

Sandro Botticelli (1445–1510)
Tempera on canvas, 172.5 x 278.9 cm (68 x 109⅔ in)
• Galleria degli Uffizi, Florence

The Birth of Venus, *c.* 1485 Created for the Medici family, Botticelli depicts Zephyrus (carrying Chloris), blowing Venus (portrayed as a sensuous nude, based on an ancient statue), born from sea foam and carried on a shell to Cyprus, where a nymph runs to meet her.

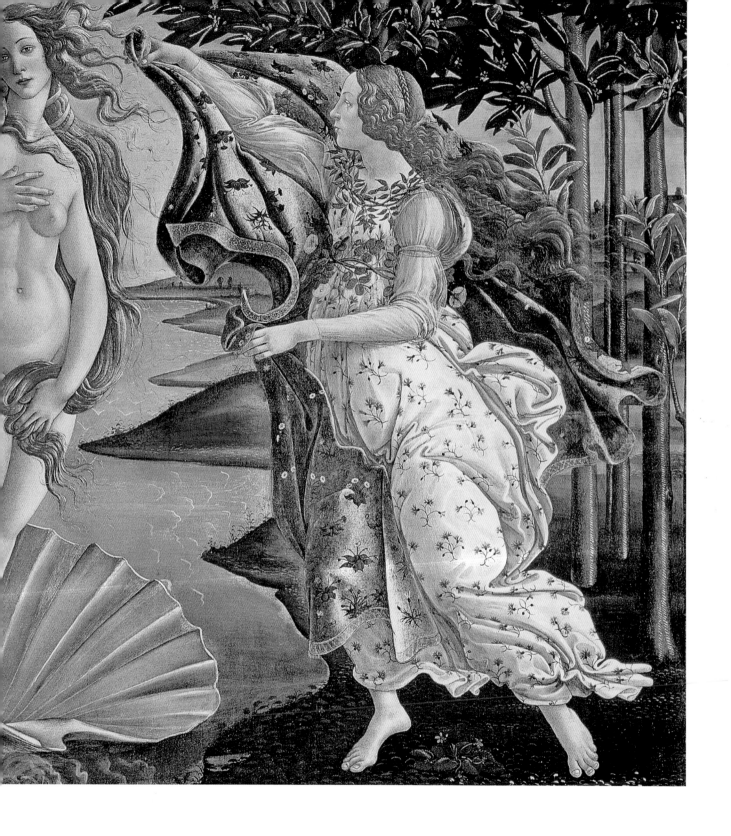

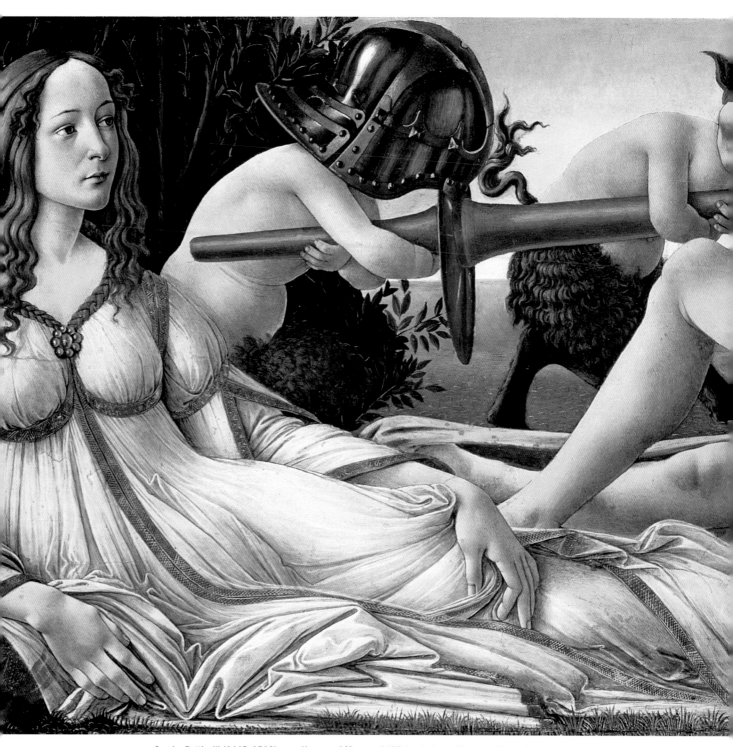

Sandro Botticelli (1445–1510)
Tempera and oil on panel, 69.2 x 173.4 cm (27¼ x 68⅓ in)
• The National Gallery, London

Venus and Mars, c. 1485 A voluptuous Venus, goddess of love, keeps watch over a sleeping Mars, god of war, surrounded by baby satyrs, reinforcing the message that love conquers all. The painting's aura of carnal sensuality suggests it was intended for a bedchamber.

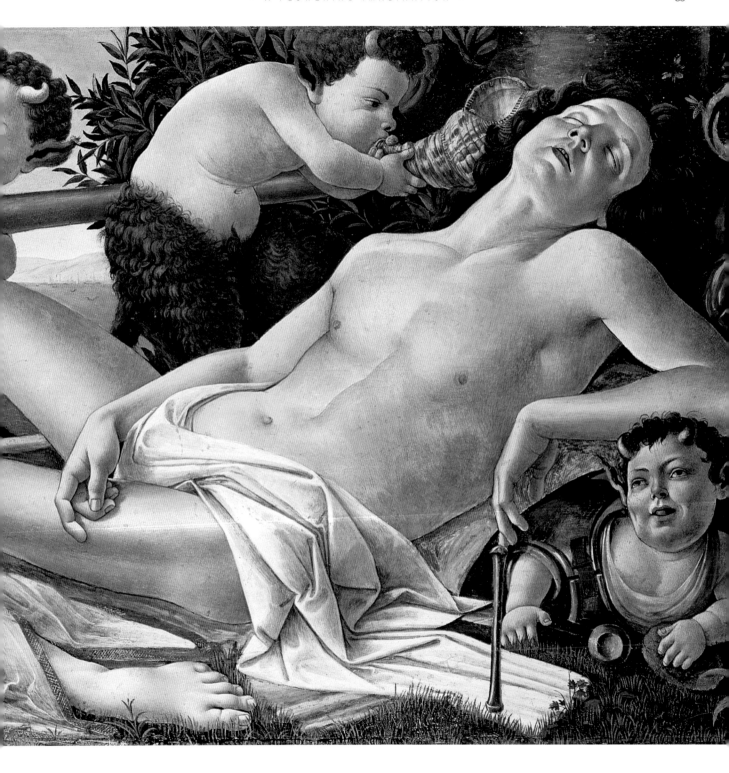

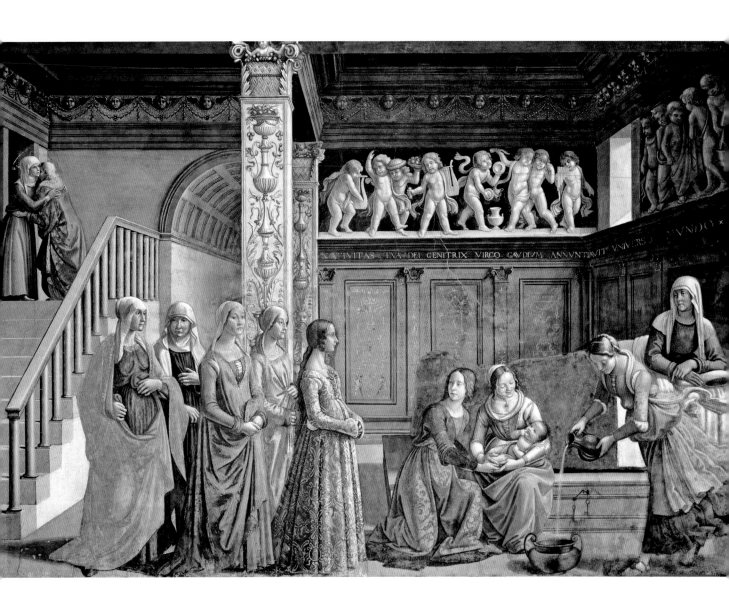

Domenico Ghirlandaio (1448–94)
Fresco, 744 x 455 cm (293 x 179 in)
• Cappella Tornabuoni, Santa Maria Novella, Florence

Birth of the Virgin, *c.* 1485–90 This scene, from Ghirlandaio's *Life of the Virgin* fresco cycle, takes place in a fashionable fifteenth-century Florentine bedroom. Saint Anne and the baby Mary are attended by recognizable, sumptuously dressed members of the Tornabuoni family.

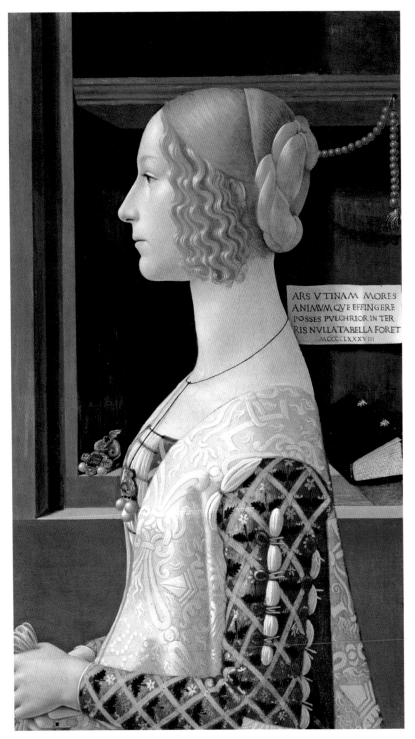

In the painting, the inscription reads:

ARS VTINAM MORES
ANIMVM QVE EFFINGERE
POSSES PVLCHRIOR IN TER
RIS NVLLA TABELLA FORET
MCCCCLXXXVIII

Domenico Ghirlandaio (1448–94)
Tempera on panel, 77 x 49 cm (30 x 19 in)
• Museo Thyssen-Bornemisza, Madrid

Portrait of Giovanna Tornabuoni, 1488 Giovanna, wearing a lavish brocaded gown, appears in strict profile, sporting the very latest Florentine hairstyle and valuable jewels around her neck. The *cartellino* (small piece of paper) behind her records an epigram by a poet from ancient Rome.

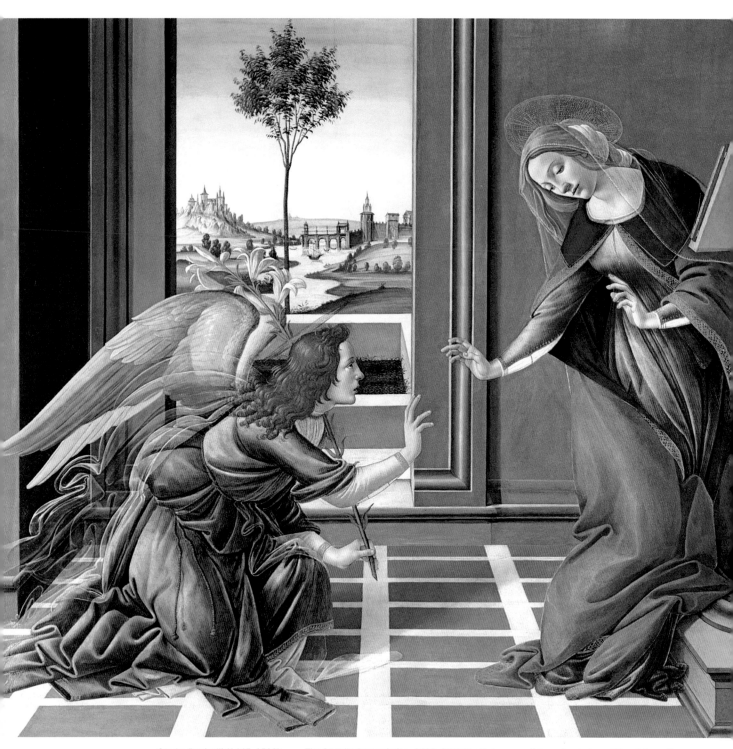

Sandro Botticelli (1445–1510)
Tempera on panel, 150 x 156 cm (59 x 61 in)
• Galleria degli Uffizi, Florence

The Cestello Annunciation, 1489–90 Botticelli drew on religious plays to invest his painting with psychological intensity. Powerful diagonals convey the sense of communication between the figures. Gabriel's floating robes suggest he has just landed in the room (structured according to the laws of perspective).

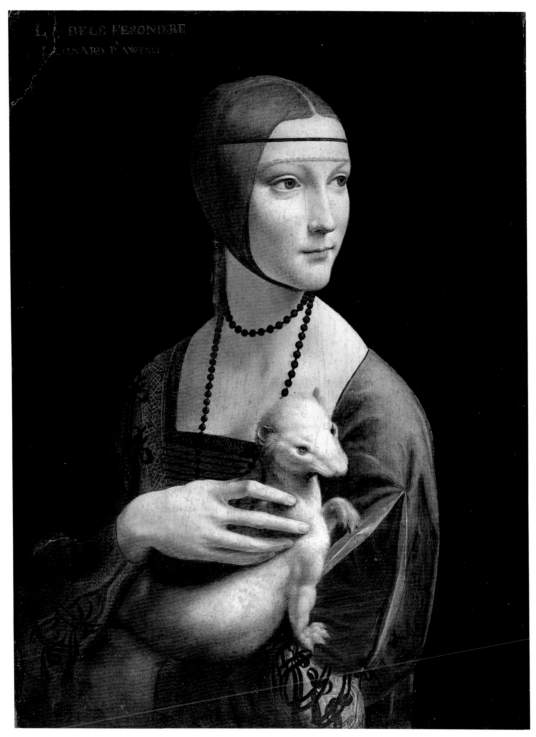

Leonardo da Vinci (1452–1519)
Oil on walnut panel, 54.8 x 40.3 cm (21⅗ x 16 in)
• National Museum, Cracow

Portrait of Cecilia Gallerani (Lady with an Ermine), 1489–90 Cecilia Gallerani (1473–1536) was 16 years old and the mistress of Ludovico Sforza (1452–1508), ruler of Milan, when Leonardo painted her. Ironically, the ermine she holds was regarded as a symbol of purity. It was also Ludovico's personal heraldic emblem.

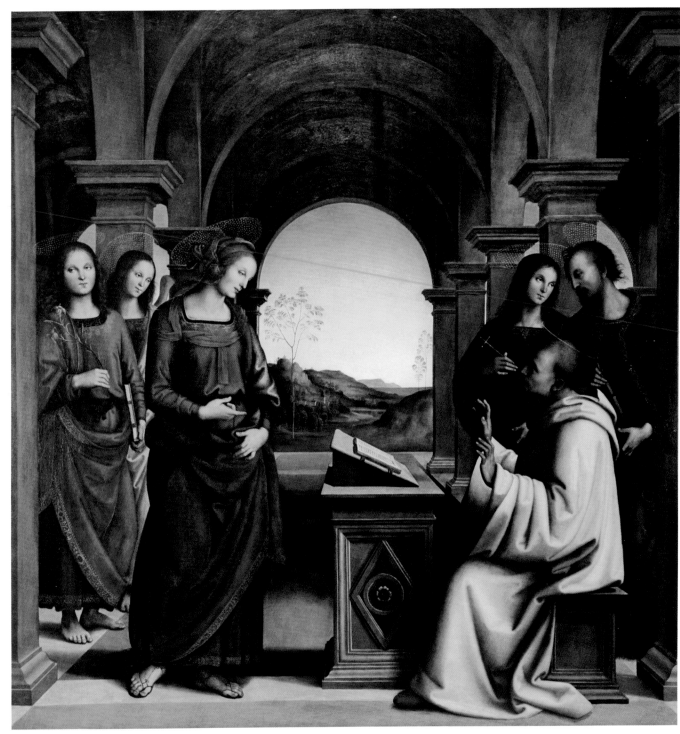

Pietro Perugino (*c.* 1446-1523)
Oil on wood, 173 x 170 cm (68 x 67 in) • Alte Pinakothek, Munich

The Virgin Appearing to St Bernard, *c.* 1490–94 According to legend, the Virgin appeared in a vision to Saint Bernard of Clairvaux (1090–1153), the founder of the Cistercian order. In this harmonious, symmetrical composition, the figures are framed by arches and columns.

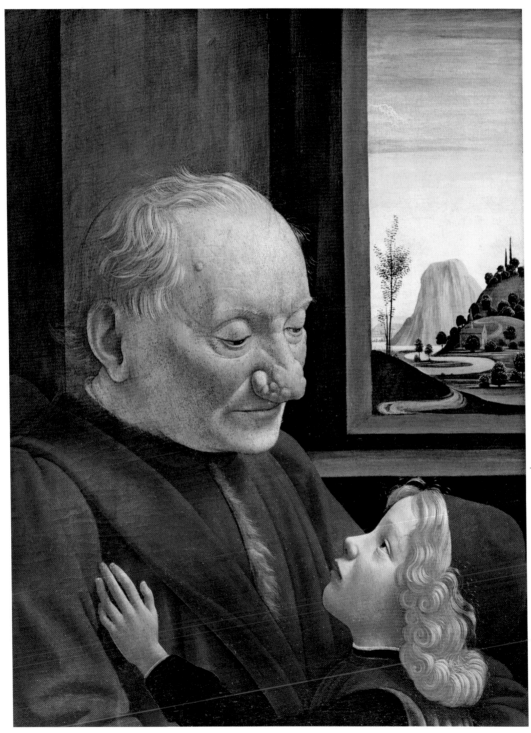

Domenico Ghirlandaio (1448–94)
Tempera on wood, 62.7 x 46 cm (24¾ x 18⅓ in)
• Musée du Louvre, Paris

An Old Man and his Grandson, _c._ 1490 In this touching portrait, Ghirlandaio balances the beauty of the golden-haired little boy with the face of the old man, whose nose appears to be disfigured by a skin condition.

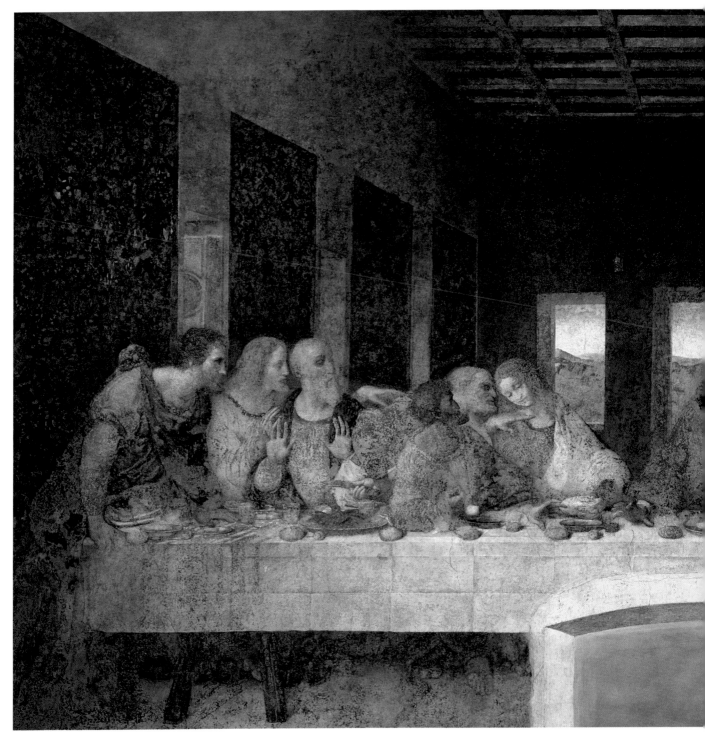

Leonardo da Vinci (1452–1519)
Tempera and oil on plaster, 460 x 880 cm (180 x 350 in)
• Santa Maria delle Grazie, Milan

Last Supper, *c.* 1495–98 One of the greatest triumphs and biggest tragedies in art history, Leonardo communicates the varied human emotions and drama of the Last Supper, but his use of an untested medium has caused the work to deteriorate.

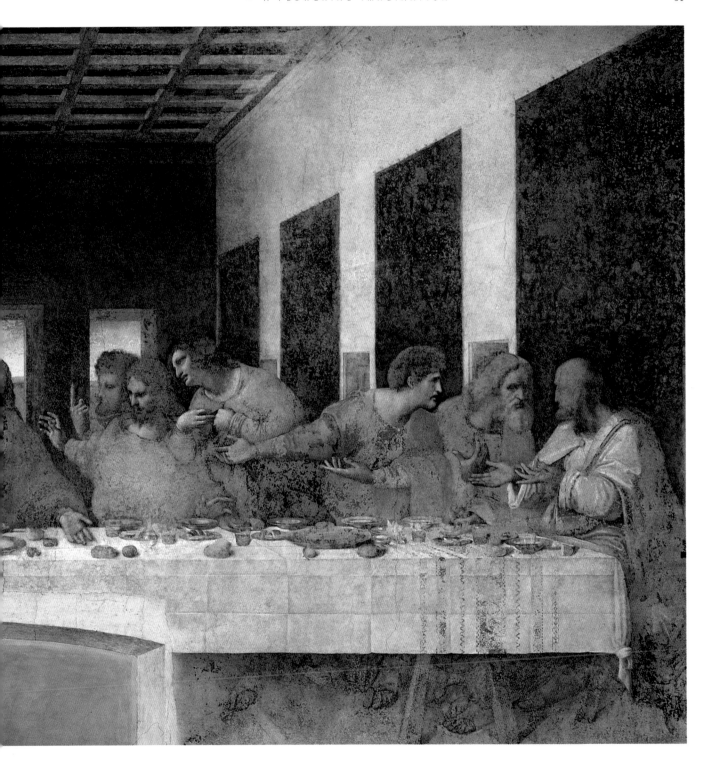

Sandro Botticelli (1445–1510)
Oil on canvas, 108.6 x 74.9 cm (43 x 29½ in)
• The National Gallery, London

Mystic Nativity, 1500 This unconventional picture combines Jesus's birth, celebrated by angels, with a vision of his Second Coming (his return to Earth), prophesied in the Book of Revelation – a theme that featured in many of Girolamo Savonarola's (1452–98) sermons.

Pietro Perugino (c. 1446–1523)
Oil on panel, 236 x 186 cm (93 x 73⅓ in)
• Musée des Beaux-Arts, Caen

Marriage of the Virgin, 1500–04 Applying balance, proportion and linear perspective (the piazza has a precise grid pattern), Perugino's portrayal of the marriage between Mary and Joseph was painted for Perugia Cathedral, where the Virgin's engagement ring was kept as a relic.

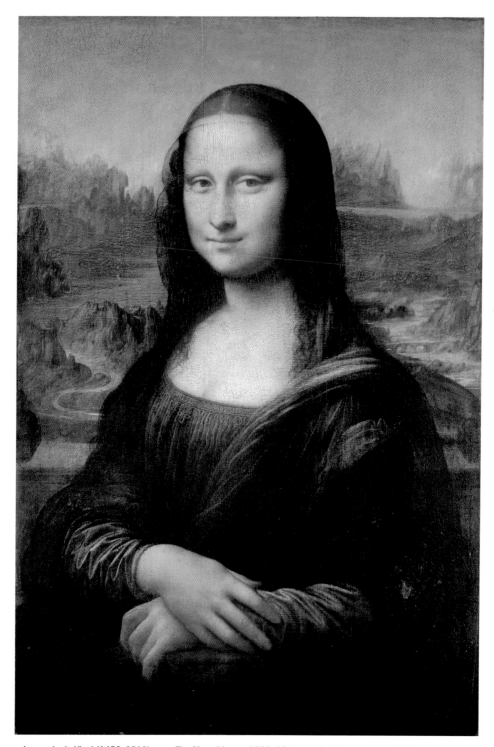

Leonardo da Vinci (1452–1519)
Oil on panel, 77 x 53 cm (30.3 x 21 in)
• Musée du Louvre, Paris

The Mona Lisa, *c.* **1503–05** A portrait of Lisa Gherardini (1479–1542), wife of a Florentine merchant, Leonardo uses *sfumato* or soft focus, to create the illusion of volume, allowing light to emerge from the darkness of shadow. The woman's enigmatic expression is captivating.

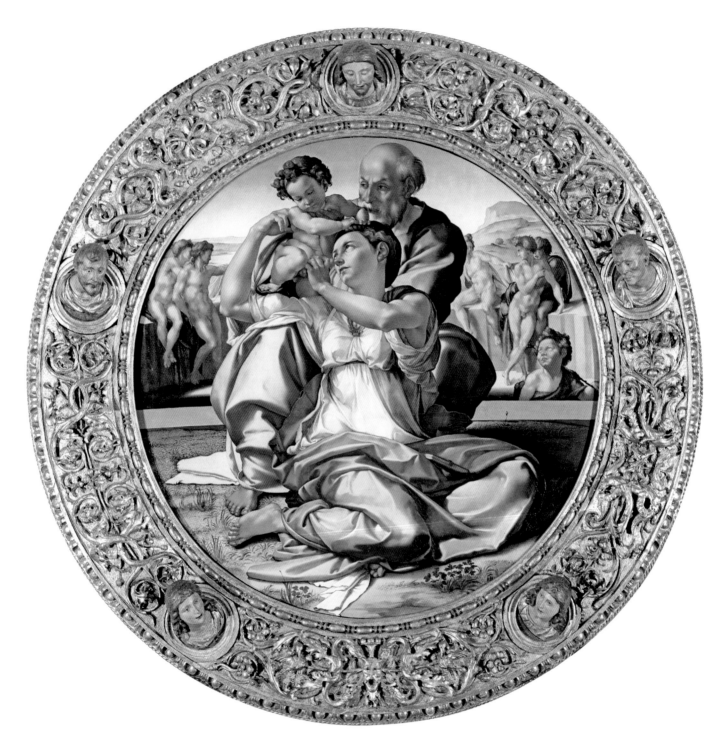

Michelangelo Buonarotti (1475-1564)
Oil and tempera on panel, diameter 120 cm (47¼ in)
• Galleria degli Uffizi, Florence

Doni Tondo, 1505–06 This circular painting of the Holy Family was created by Michelangelo (who also designed the frame) for Agnolo Doni (1474–1539), probably to celebrate his marriage to Maddalena Strozzi (1489–1540). The sculptural figures, spiralling movements and bold colours are highly expressive.

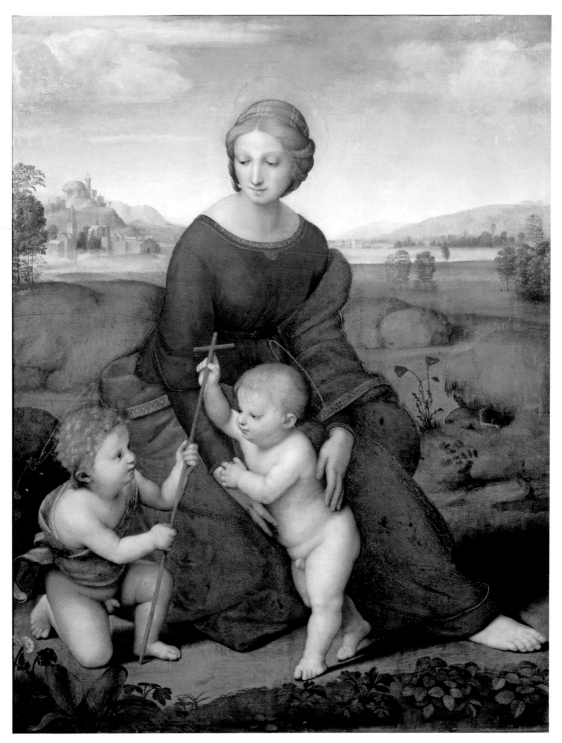

Raphael (Raffaello Sanzio, 1483–1520)
Oil on panel, 113 x 88.5 cm (44 x 35 in)
• Kunsthistorisches Museum, Vienna

Madonna del Prato, 1505–06 In this painting of the 'Madonna of the Meadow' Raphael borrows from Leonardo (in the pyramid structure and modelling of forms) and Michelangelo. The sweeping landscape gives the work an idyllic feel.

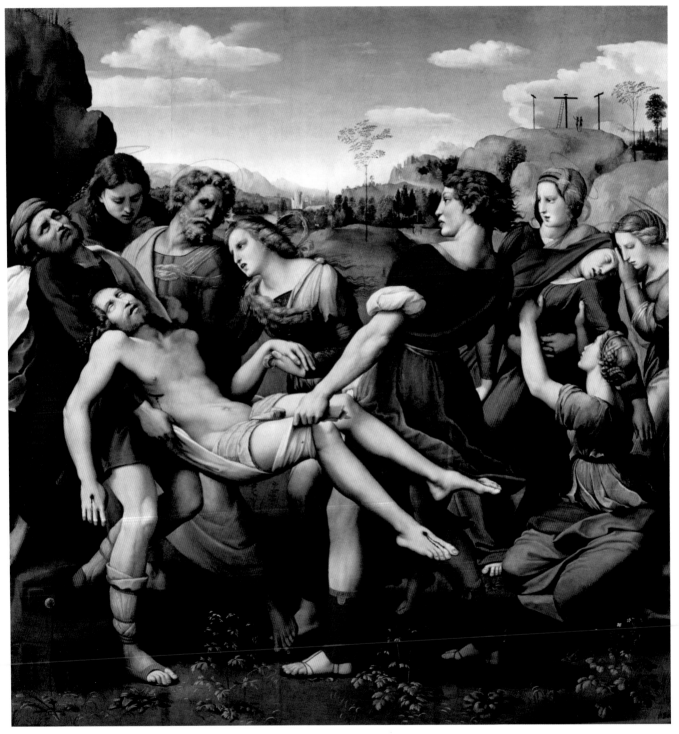

Raphael (Raffaello Sanzio, 1483–1520)
Oil on panel, 184 x 176 cm (72 x 69 in)
• Galleria Borghese, Rome

The Deposition, 1507 Painted for Atalanta Baglioni in memory of her son, Grifonetto (killed during a family feud), Michelangelo's influence on the young Raphael is evident. The kneeling woman at the extreme right is taken straight from Michelangelo's *Doni Tondo*.

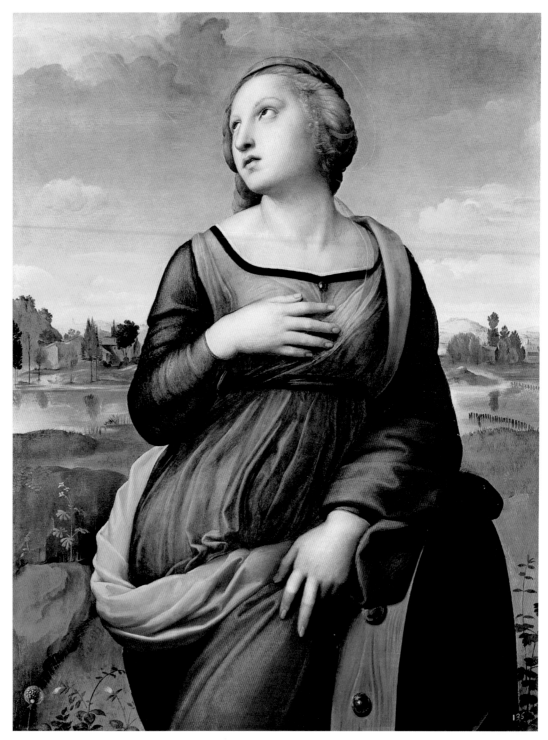

Raphael (Raffaello Sanzio, 1483–1520)
Oil on panel, 71.5 x 55.7 cm (28 x 22 in)
• The National Gallery, London

Saint Catherine of Alexandria, *c.* 1507 Painted just before Raphael's move to Rome, Saint Catherine's dynamic pose is based on the artist's study of Leonardo's works. The saint, leaning on her attribute – the wheel – turns enraptured towards a heavenly light.

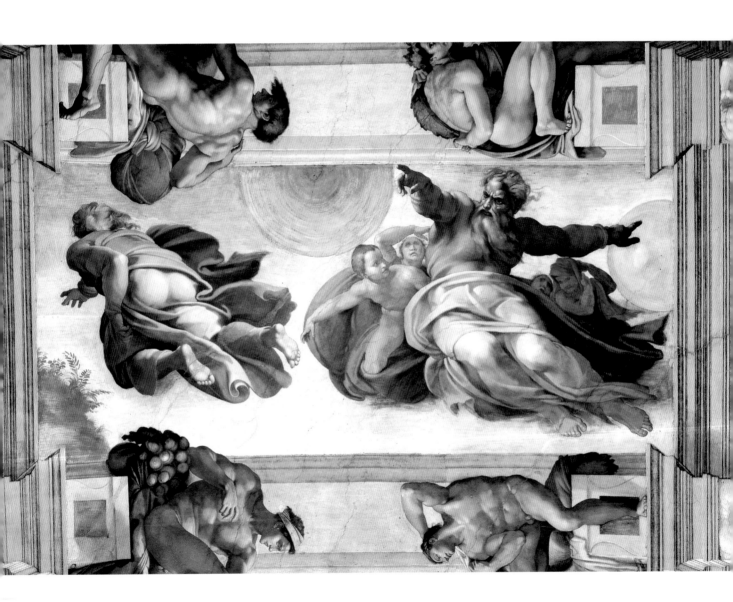

Michelangelo Buonarotti (1475–1564)
Fresco, 280 x 570 cm (110¼ x 224⅔ in)
• Sistine Chapel, Vatican Museums, Rome

The Creation of the Sun, Moon and Plants, c. 1508–12 Michelangelo painted the panels of the Sistine Chapel ceiling, one of the jewels of Western art, in reverse chronological order – this is actually the penultimate scene he worked on. Two images of an imposing, muscular God are represented – this was the first time God had been depicted in this energetic way.

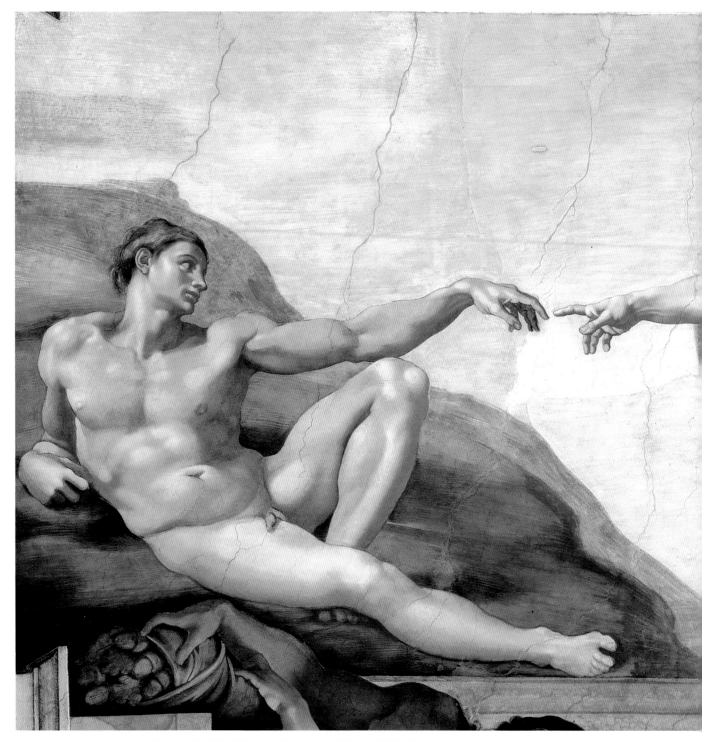

Michelangelo Buonarotti (1475–1564)
Fresco, 280 x 570 cm (110¼ x 224⅔ in)
• Sistine Chapel, Vatican Museums, Rome

The Creation of Adam, *c.* **1508–12** In this iconic scene from the Sistine Chapel ceiling, Michelangelo depicts God, wrapped in a cloud of billowing drapery, reaching out and transmitting life-giving power to the heavy figure of Adam.

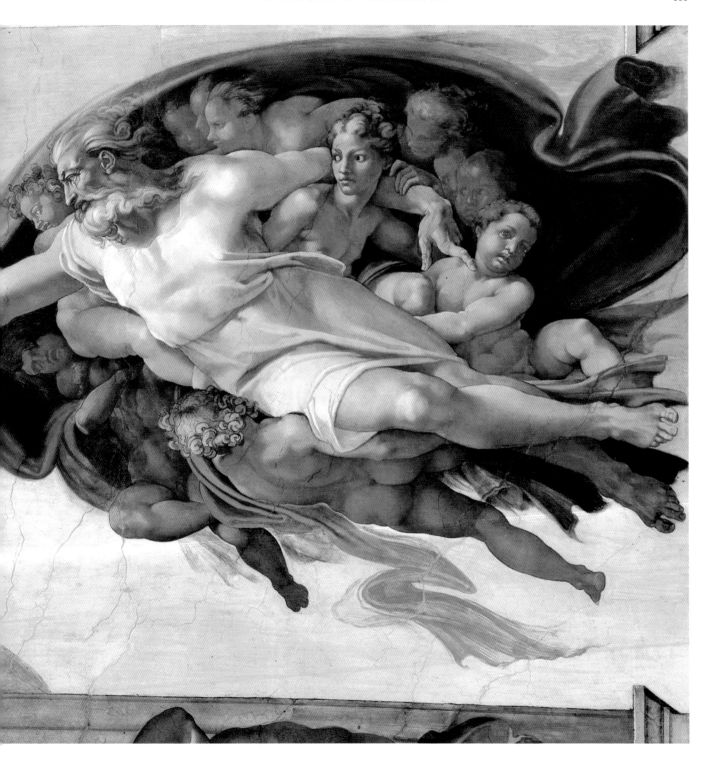

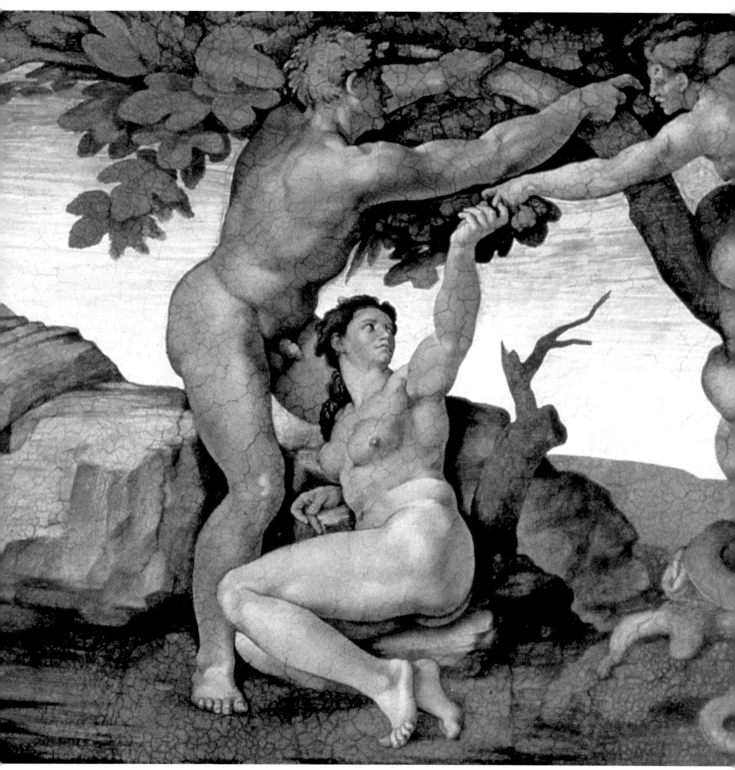

Michelangelo Buonarotti (1475–1564)
Fresco, 280 x 570 cm (110¼ x 224⅔ in)
• Sistine Chapel, Vatican Museums, Rome

The Fall of Man, *c.* **1508–12** This rhythmic composition flows from Adam and Eve (left), to the Tree of Knowledge with its female tempter (centre) and the fallen pair, now aged, banished from Paradise (right). The bodies of the figures are painted with a sculptor's eye.

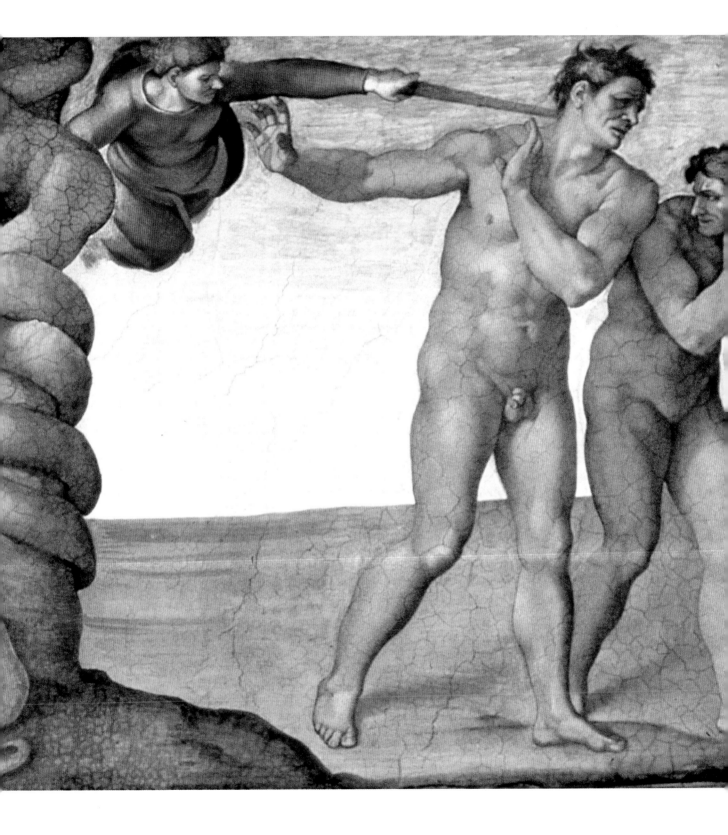

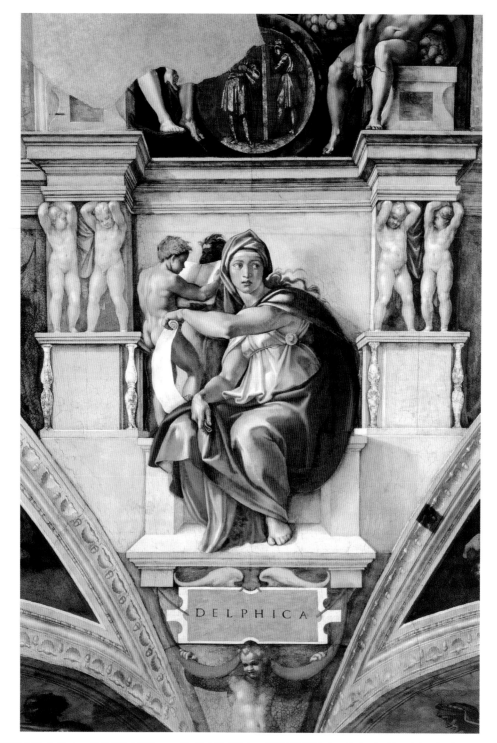

Michelangelo Buonarotti (1475–1564)
Fresco, 350 x 380 cm (138 x 150 in)
• Sistine Chapel, Vatican Museums, Rome

The Delphic Sibyl, *c.* **1508–12** Michelangelo, inspired by ancient Greek and Roman art and architecture, gives this prophetic figure a monumental form, which seems to project outwards from the ceiling's surface. The twisting pose reinforces the sense of balance in the circular composition.

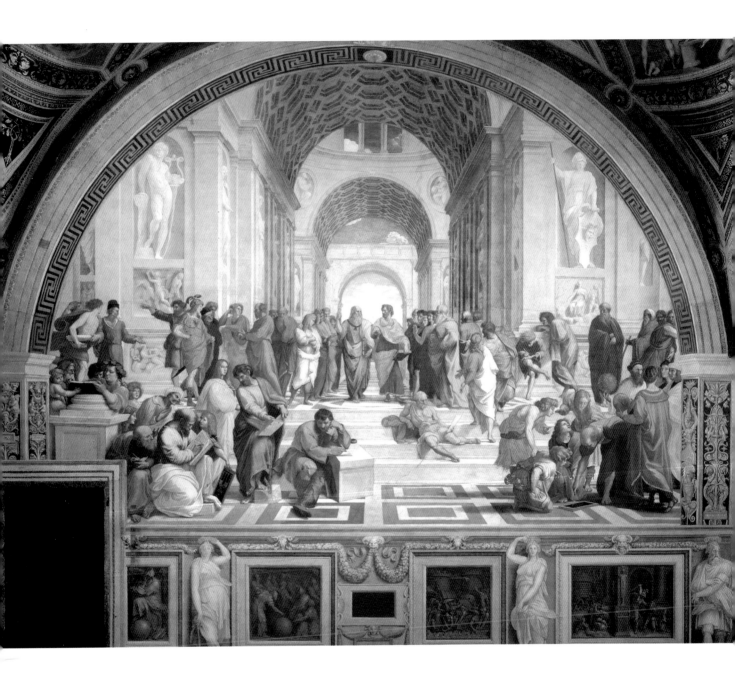

Raphael (Raffaello Sanzio, 1483–1520)
Fresco, 500 x 770 cm (197 x 303¼ in)
• Stanza della Segnatura, Vatican Museums, Rome

The School of Athens, 1509–11 A celebration of Classical thought, the individuals and groups of figures here are carefully related to one another, forming an interlocking pattern leading to the centre, where Plato and Aristotle stand.

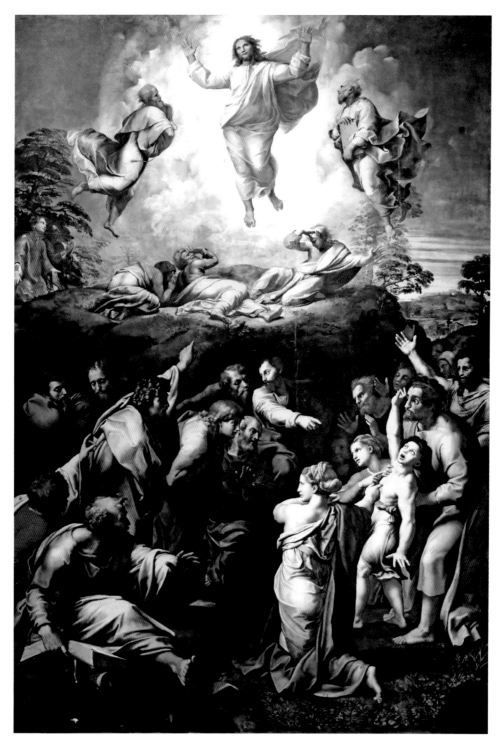

Raphael (Raffaello Sanzio, 1483–1520)
Tempera on wood, 405 x 278 cm (159 x 109 in)
• Pinacoteca Vaticana, Rome

The Transfiguration, 1516–20 Described by one sixteenth-century commentator as Raphael's 'most beautiful and most divine' work, this painting is split into two parts: the Transfiguration of Christ (top), with Moses and Elijah, and the Miraculous Healing of the Possessed Boy (bottom).

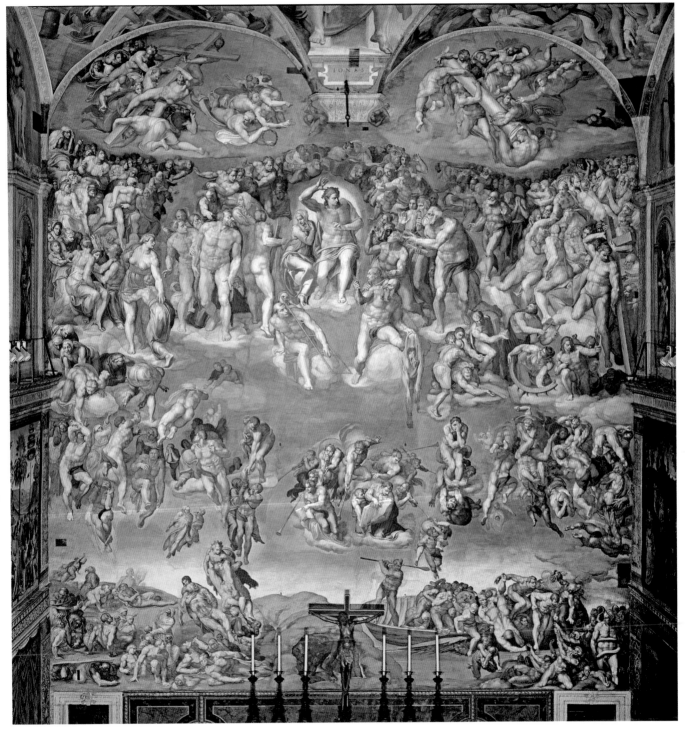

Michelangelo Buonarotti (1475–1564)
Fresco, 1370 x 1200 cm (539⅖ x 472⅖ in)
• Sistine Chapel, Vatican Museums, Rome

The Last Judgement, 1534–41 The unveiling of this vast work was greeted by controversy. Many felt Michelangelo had flouted decorum by painting so many nudes in a sacred work. Daniele da Volterra (1509–66) was commissioned to paint draperies on the offending figures.

Blooms in Profusion

From the uniquely rich Venetian style to the distinctive and devout work of the Mannerists, Italy in the sixteenth century was home to a profusion of trends and innovative images.

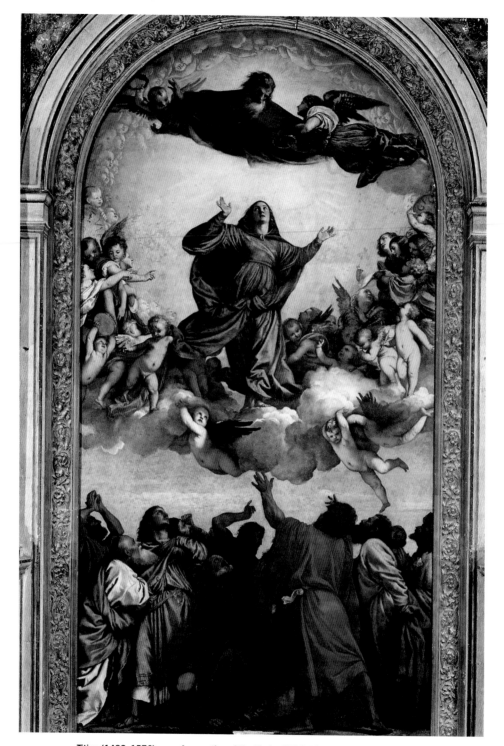

Titian (1488–1576)
Oil on panel, 690 x 360 cm (270 x 140 in)
• Basilica di Santa Maria Gloriosa dei Frari, Venice

Assumption of the Virgin, 1516–18 With this huge altarpiece, Titian brought the High Renaissance to Venice. His dramatic composition depicting the Virgin's ascent into Heaven is unified by his inventive use of light and chromatic repetition.

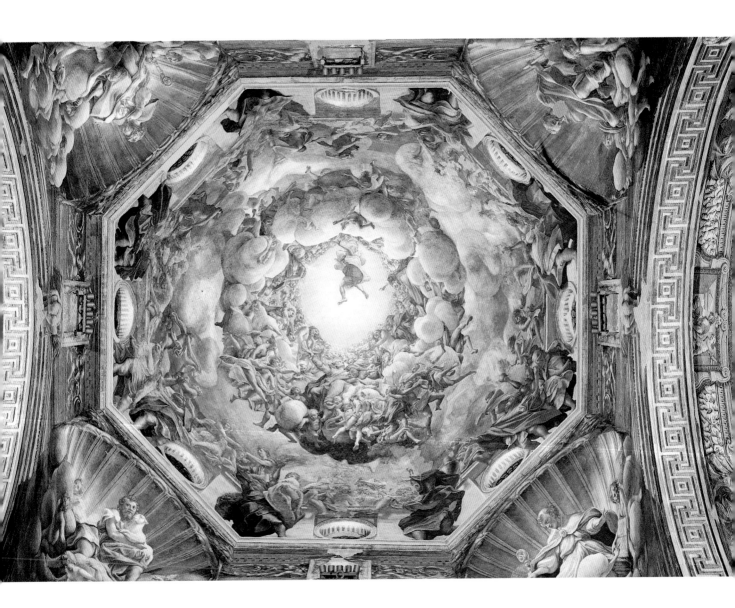

Correggio (1489-1534)
Fresco, 1093 x 1195 cm (430⅓ x 470½ in)
• Cattedrale di Santa Maria Assunta, Parma

Assumption of the Virgin, 1526–30 Full of bold foreshortening effects (best seen in the portrayal of Christ, whose legs are exposed), Correggio's fresco for the dome of Parma Cathedral is a swirling mass of figures, carried on concentric rings of clouds.

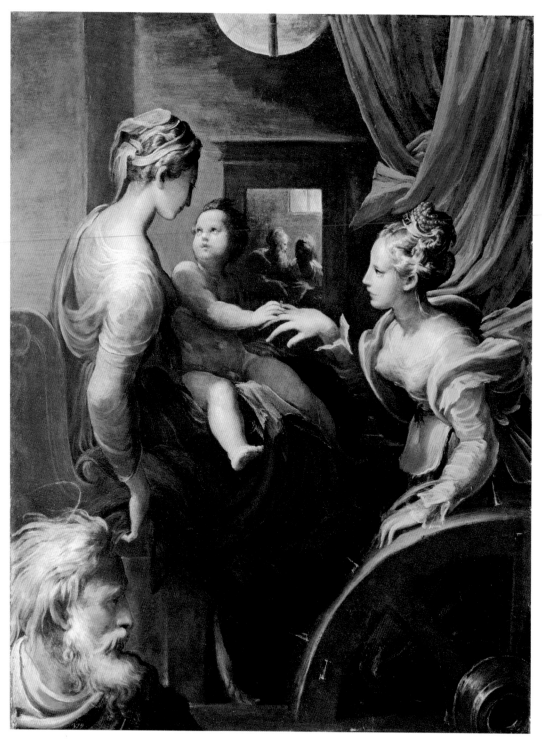

Parmigianino (1503–40)
Oil on wood, 74.2 x 57.2 cm (29¼ x 22½ in)
• The National Gallery, London

The Mystic Marriage of Saint Catherine, *c.* **1527–31** Reflecting the strong influence of Correggio on Parmigianino, this painting shows Catherine, one of the most popular female saints, and the infant Jesus; he is placing a ring on Catherine's elegant long finger in a 'mystic marriage'.

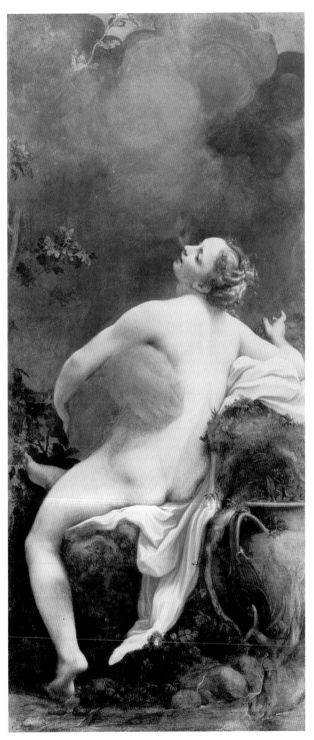

Correggio (1489–1534)
Oil on canvas, 162 x 73.5 cm (63⅘ x 29 in)
• Kunsthistorisches Museum, Vienna

Jupiter and Io, *c.* 1530 Commissioned by Federico II Gonzaga, Duke of Mantua (1500–40), this erotic painting is notable for its delicate brushwork. It depicts the god Jupiter (in the guise of a cloud) seducing the nymph Io, whose contours have striking serpentine curves.

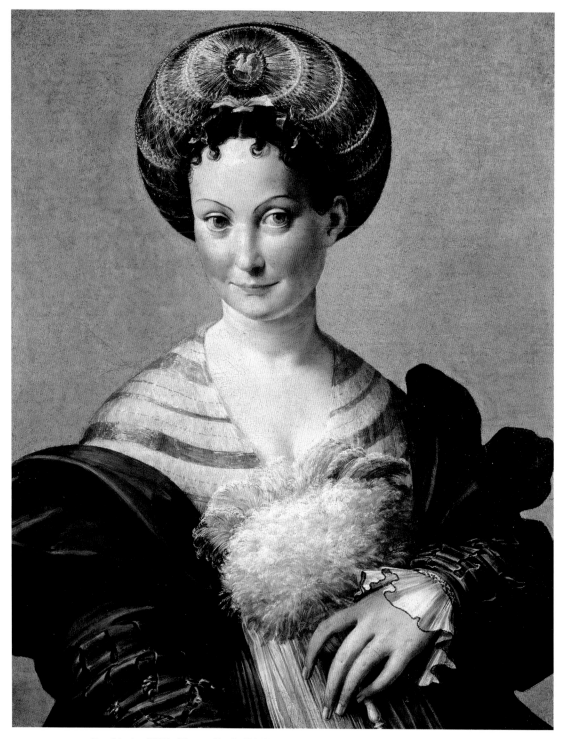

Parmigianino (1503–40)
Oil on panel, 67 x 53 cm (26 x 21 in)
• Galleria Nazionale, Parma

The Turkish Slave, c. 1533 Despite the title of this Mannerist masterpiece, the rosy-cheeked sitter wearing an elaborate turban-like hat (popular in Northern Italian Renaissance courts) was almost certainly not Turkish. She could have been a noblewoman, a courtesan or an ideal of feminine beauty.

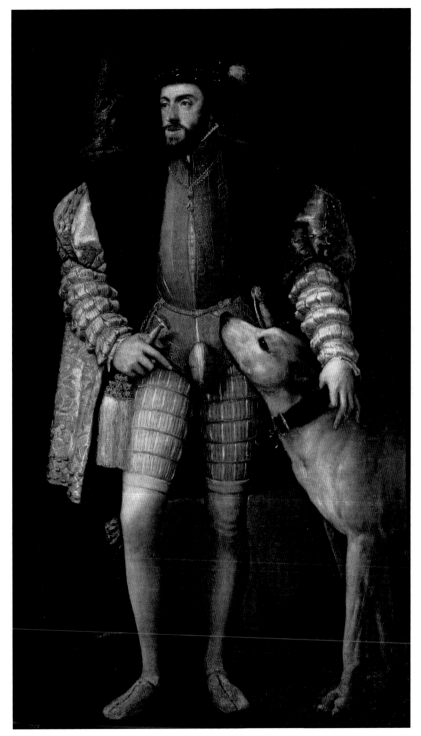

Titian (1488–1576)
Oil on canvas, 192 x 111 cm (76 x 44 in)
• Museo del Prado, Madrid

Portrait of Charles V with a Dog, 1533 The Emperor Charles V (with his large hound) fills the frame. Titian chose a lower viewpoint to suggest his subject's height, using colour in a subtle, graduated way. He may have copied a painting by Jakob Seisenegger (1505–67).

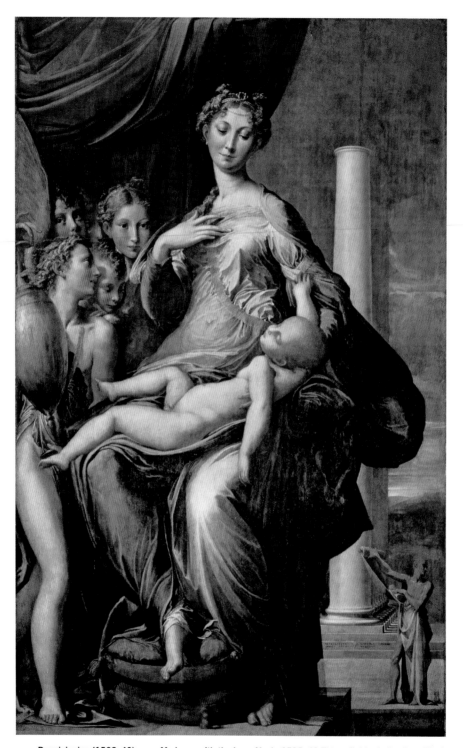

Parmigianino (1503–40)
Oil on wood, 216 x 132 cm (85 x 52 in)
• Galleria degli Uffizi, Florence

Madonna with the Long Neck, 1535–40 This unfinished altarpiece (like Leonardo, Parmigianino found it difficult to finish a work) focuses on the Madonna. Depicted on a monumental scale in cool colours, and with an extraordinarily long neck, she looks down at the sprawling baby Jesus.

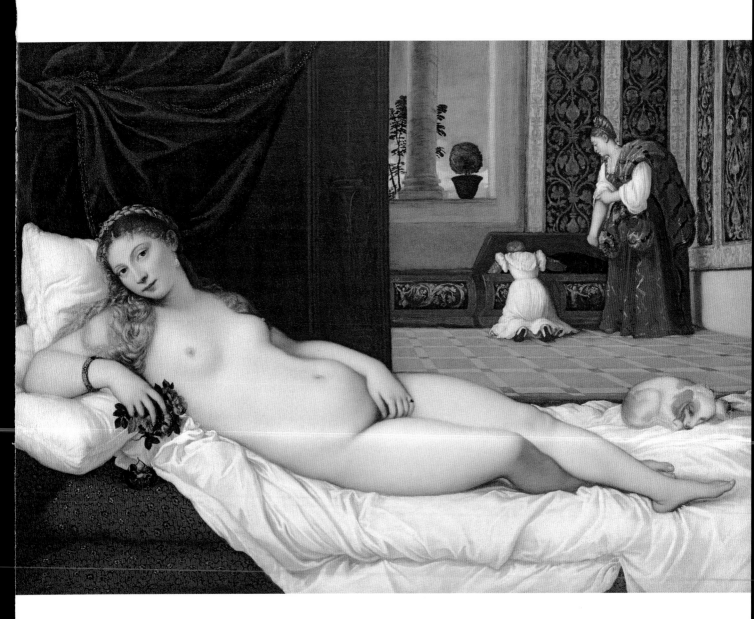

Titian (1488–1576)
Oil on canvas, 119 x 165 cm (47 x 65 in)
• Galleria degli Uffizi, Florence

Venus of Urbino, 1538 Painted for the Duke of Urbino, Guidobaldo della Rovere (1514–74), this is not really an image of the goddess Venus – the mythological title gave male beholders an intellectual 'cover story'. This is a flesh and blood woman in her bedchamber.

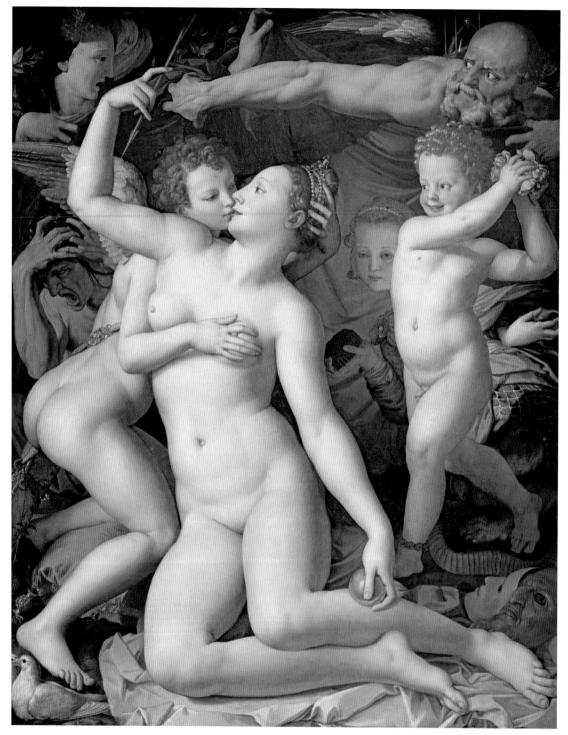

Bronzino (1503-72)

Oil on panel, 146.1 x 116.2 cm (57½ x 45¾ in)

• The National Gallery, London

An Allegory with Venus and Cupid, *c.* **1545** Obscure but lascivious imagery abounds. Crowded into a compressed foreground space, Cupid fondles his mother Venus (both have porcelain-like skin and typical Mannerist spiralling poses), while Folly throws rose petals at them. Other figures include Time, Jealousy and Fraud.

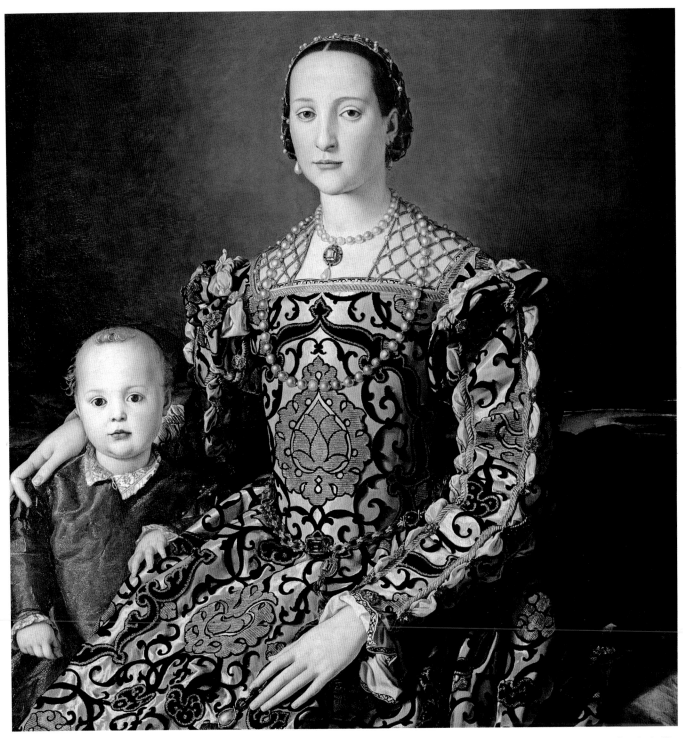

Bronzino (1503–72)
Oil on panel, 115 x 96 cm (45 x 38 in)
• Galleria degli Uffizi, Florence

Portrait of Eleonora of Toledo with her son Giovanni, *c.* 1545 This portrait is meant to testify to the fertility of the duchess Eleonora (1519–62), pictured here (looking aloof in an elaborately decorated gown) with her second son Giovanni. Set against a blue background, Eleonora almost appears to have a halo.

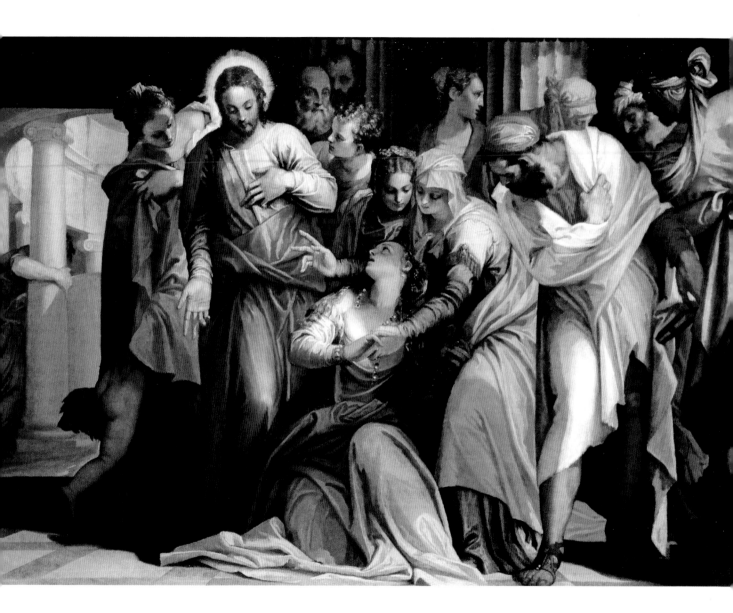

Paolo Veronese (1528-88)
Oil on canvas, 117.5 x 163.5 cm (46⅓ x 64½ in)
• The National Gallery, London

The Conversion of Mary Magdalene, c. 1548 Categorized with Titian and Tintoretto as one of the 'great trio' of Venetian High Renaissance artists, Veronese shows Mary Magdalene falling to her knees with shame as she sees Jesus. The brilliant colours and compositional structure recur throughout Veronese's works.

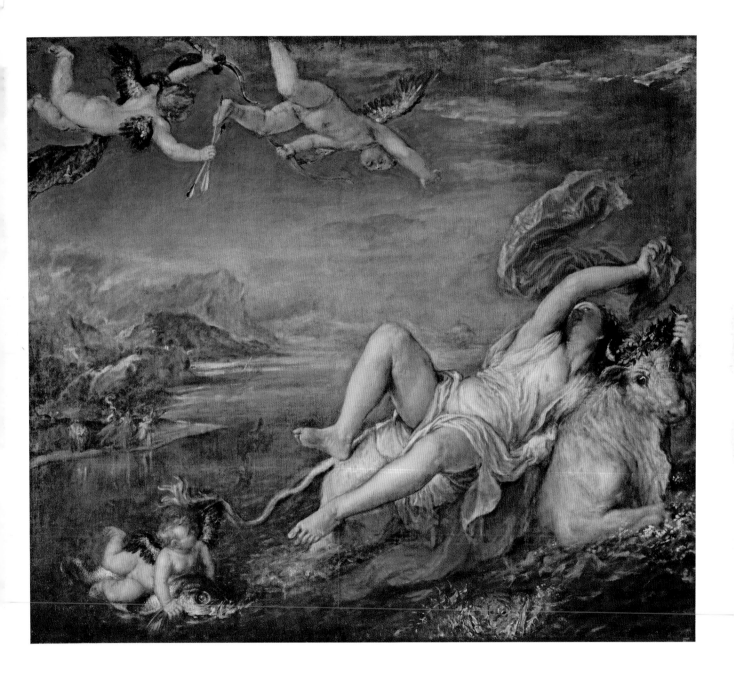

Titian (1488–1576)
Oil on canvas, 178.7 x 205.5 cm (70⅜ x 81 in)
• Isabella Stewart Gardner Museum, Boston

The Rape of Europa, 1560–62 In this giant canvas, Europa is being carried off by Jupiter, in the form of a bull, who ploughs through the waves towards Crete. Titian's flickering brushstrokes and fantastical sky and mountains add to the painting's palpable tension.

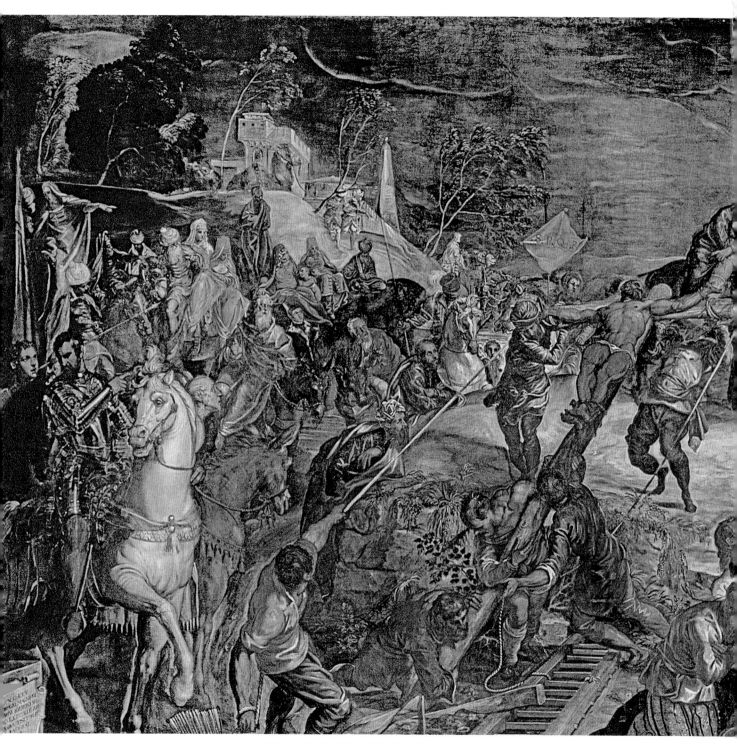

Tintoretto (1518–94)
Oil on canvas, 536 x 1224 cm (211 x 482 in)
• Scuola Grande di San Rocco, Venice

The Crucifixion, 1565 One of Tintoretto's greatest works, the artist here combines iconic and narrative modes of religious painting. Using dramatic spatial effects, bold brushwork and his light-on-dark technique, crowds of figures swirl around Christ fixed to the cross.

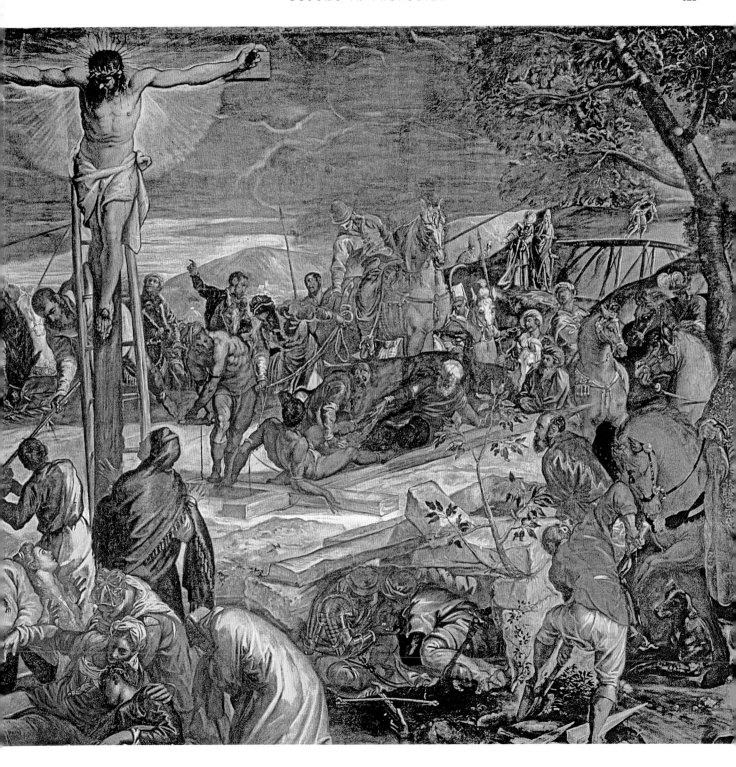

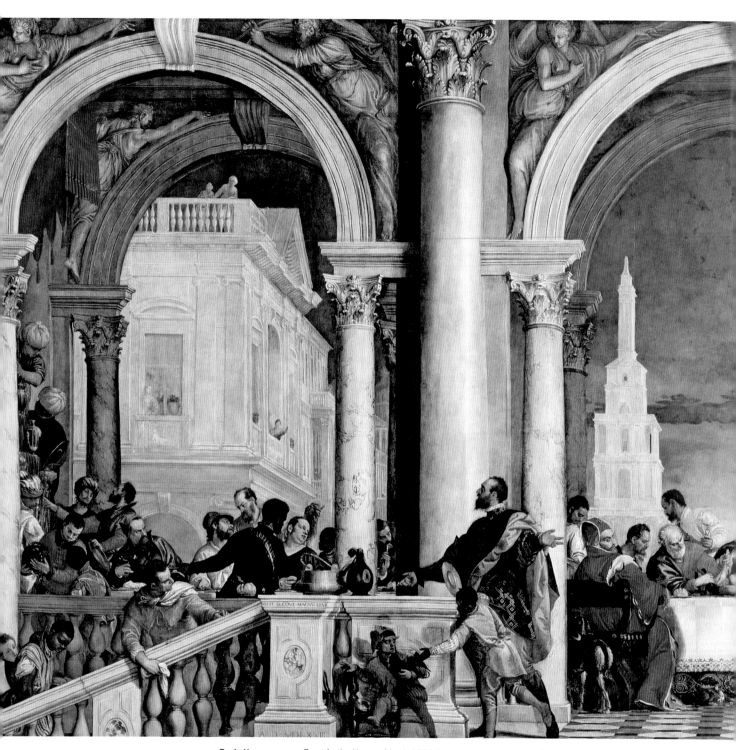

Paolo Veronese
Oil on canvas, 555 x 1280 cm (218½ x 504 in)
• Gallerie dell'Accademia, Venice

Feast in the House of Levi, 1573 Framed by portico arches, Christ seems to be sitting down to a typical Venetian banquet, surrounded by diners, waiters and entertainers. Veronese remarked, 'Mine is no art of thought; my art is joyous and praises God in light and colour.'

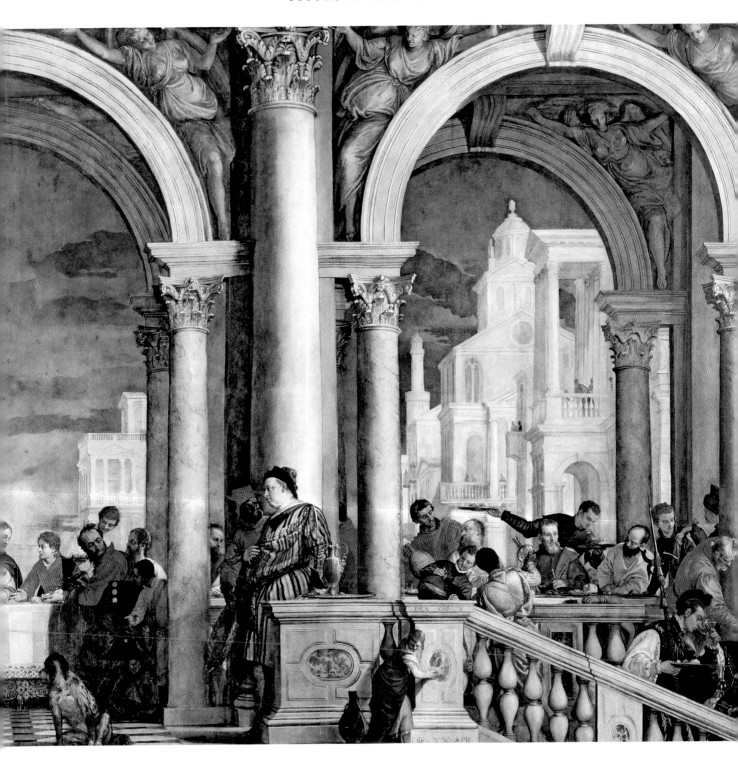

Indexes

Index of Work

General Index

Page numbers in *italics* refer to illustrations.

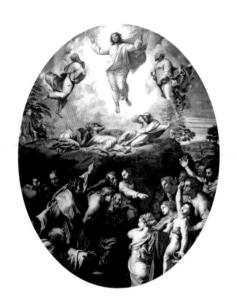

Masterpieces of Art
FLAME TREE PUBLISHING

A new series of carefully
curated print and digital books
covering the world's greatest
art, artists and art movements.

If you enjoyed this book please sign up for updates,
information and offers on further titles in this series at
blog.flametreepublishing.com/art-of-fine-gifts/